IMAGES
of Sports

NEW HAMPSHIRE
ON SKIS

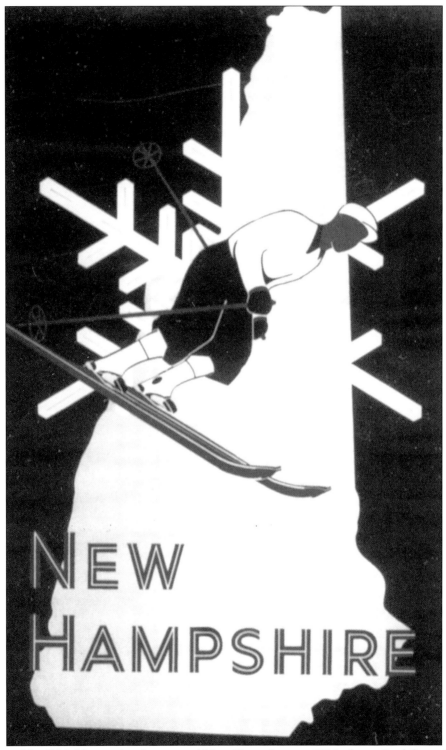

Designed by E.H. Hunter for the state of New Hampshire in 1935, the stylized figure looks remarkably like Ted Hunter in action.

IMAGES
of Sports

NEW HAMPSHIRE
ON SKIS

E. John B. Allen

ARCADIA
PUBLISHING

Published by Arcadia Publishing
Charleston, South Carolina

Printed in the United States of America

Library of Congress Catalog Card Number: 2002110594

For all general information contact Arcadia Publishing at:
Telephone 843-853-2070
Fax 843-853-0044
E-mail sales@arcadiapublishing.com
For customer service and orders:
Toll-Free 1-888-313-2665

Visit us on the Internet at www.arcadiapublishing.com

Dedicated to past, present, and future members of the
New England Ski Museum in Franconia, New Hampshire.

CONTENTS

ACKNOWLEDGMENTS

Most of the images in this book come from the collections of the New England Ski Museum. Others are from my own collection. I would like to thank the museum staff, Linda Bradshaw, Liz Lambregtse, and Jeff Leich for help at various times. I have also received help from Stacy Lopes of Waterville Valley and Loon, from Andrew Noyes and Ted Sutton of Loon, and from my wife, Heide Allen. I thank Stuart Wallace for help with New Hampshire history and Phil Haskell for technical help with my computer, both of Plymouth State College. I owe special thanks to the New Hampshire Historical Society for permission to publish the top photograph on page 32 and to Herbert Schneider for the top photograph on page 62.

INTRODUCTION

Norwegian immigrants, guardians of a 5,000-year-old history of skiing, brought this winter culture to the United States in the latter part of the 19th century. The majority settled in the Midwest, but a few found their way to the North Country, making their homes in Norway Village, which later became the logging town of Berlin. Norwegian skiing consisted of cross-country and jumping, and Berlin became a major center of skiing from the 1880s right up to World War II. Two Nansen Club members represented the United States in the Lake Placid Winter Olympics of 1932.

Interest in the outdoors was also shown by Dartmouth students in the first decade of the 20th century. With the founding of the Dartmouth Outing Club (DOC) in 1909, the college came to play a pivotal role in the development of the sport, not just among collegiate skiers, nor just in the state, but throughout New England and, indeed, over the entire country where skiing took place. In every Olympics starting in 1924 to the aborted 1940 games, DOC members were on the squad, and Dartmouth has continued that tradition in many of the post–World War II winter Olympics as well.

In the 1930s, the Norwegian culture of cross-country skiing and jumping was challenged by another form of skiing associated with the Alps in Europe—hence Alpine skiing: downhill and slalom. It attracted the well-to-do. A number of Germans, Austrians, a few Swiss, and an occasional Frenchman immigrated to the United States from the Alpine playground of Europe, which was embroiled in the political mayhem of the 1930s. The lucky ones found winter employment as ski instructors. There was a moment in the 1930s when having the right accent, a Tyrolean hat, and some ski knowledge could land a man a winter job. Soon the licensing of instructors was required, and New Hampshire led the way.

The state also boasted numerous rope tows, the second-in-the-nation chairlift, and the ride of all rides, the Cannon Mountain Aerial Tramway, which opened in 1938. Civilian Conservation Corps (CCC) labor was hauled in to build trails, and the Boston and Maine Railroad brought an increasing number of city folk north for skiing.

World War II put the state's burgeoning ski business on hold. New England and especially New Hampshire supplied the core of the 10th Mountain Division, the U.S. mountain troops. They trained in Colorado and saw service in the Aleutian Islands and in Italy.

Once the war ended, there was an immediate wish to get back to the ski fields. In the following quarter century, small mom-and-pop rope tow areas seemed to spring up everywhere. Many of them failed. With the latest count, there are 156 "lost" ski areas in the state. In the 1940s and 1950s, these small areas gave many a youngster the opportunity to ski. They then went on to the larger areas now being built in the state. The infusion of capital created major

developments with the ever-increasing sophistication of equipment. There seemed no end to the expansion—until the oil embargo of the early 1970s.

Today, no area can be without its snowcats and grooming equipment, without an adequate water supply for snowmaking, and aggressive marketing is vital. More important still is the modern ski areas' tie in with real-estate development. Hence, skiing has become just one of the activities for a captive clientele in their condominiums. A number of the ski resorts that used to be so competitive—Loon and Waterville, for example—are now part of a nationwide resort conglomerate, which in this case includes six resorts from Maine to California. I have used the word "skiing," but these days that honorable word has to share billing with "riding" and snowboard parks, with half-pipes and aerial terrain, and snow sport schools. For those on skis, whether in 1902 or 2002, the thrill is the same: the bite of frost in the air as the snow crackles under the gliding ski in the woods, the pulse of heart and muscle as body and mind tackle New Hampshire's white hills for the thrilling downhill schuss.

This collection of images, all preserved within the museum, contains work by the more renowned ski photographers and artists: Dwight Shepler, Ted Hunter, Christine Reid, Warren Bartlett, Charles Trask, and Winston Pote. I have also drawn on my previous works: "The Development of New Hampshire Skiing, 1870s–1940," *Historical New Hampshire* XXXVI, 1 (Spring 1981): 1-37; "Values and Sport: The Development of New England Skiing, 1870–1940," *Oral History Review* 13 (1985): 55-76; *From Skisport to Skiing: One Hundred Years of an American Sport, 1840–1940*. Amherst: University of Massachusetts Press, 1993.

One

ADVERTISING
NEW HAMPSHIRE

New Hampshire—a Great Out-O-Door State.
—Advertisement from 1938.

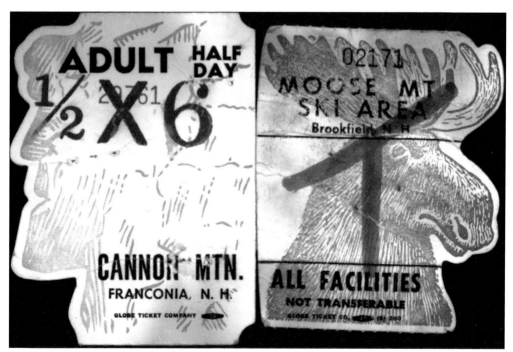

Cannon Mountain capitalized on the Great Stone Face on the lift ticket, while Moose Mountain in Brookfield, now one of the "lost" ski areas, used a moose as a symbol.

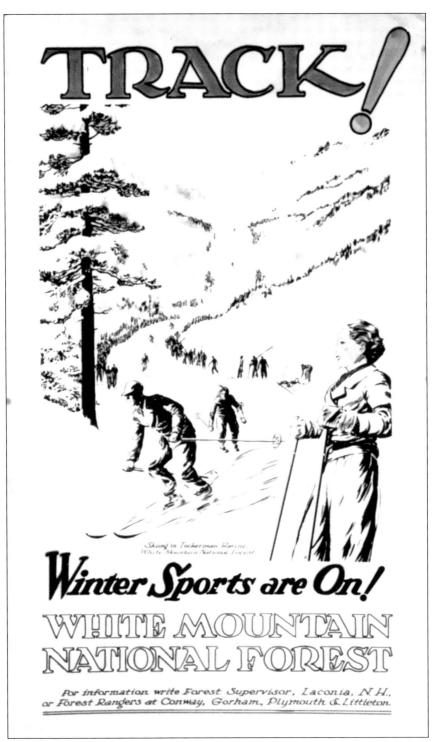

TRACK!

Skiing in Tuckerman Ravine.
White Mountain National Forest

Winter Sports are On!

WHITE MOUNTAIN NATIONAL FOREST

For information write Forest Supervisor, Laconia, N.H.,
or Forest Rangers at Conway, Gorham, Plymouth & Littleton.

"Track!" was a new expression in the 1930s. It meant "Watch out, move over, I am coming through." As more people took to skiing, development grew apace in the 1930s. In the White Mountain National Forest and on other state lands, it meant much government involvement.

The State Planning and Development Commission's posters of the 1930s appealed to two different sorts of clientele. The chic lady in the latest fashions looks as if she might have stepped straight out of Saks Fifth Avenue store, which is precisely the intent. New Hampshire successfully wooed the New York ski-train crowd in the mid-1930s. The bare-chested fellows skiing the spring days away at Tuckerman let the graduated and college men know that "the Bowl" was the place to be on spring weekends.

NEW HAMPSHIRE

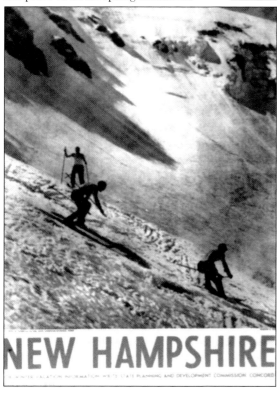

NEW HAMPSHIRE

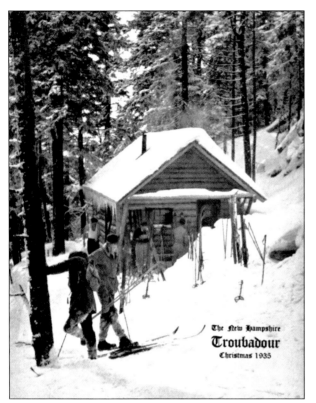

The *Troubadour* was a small monthly magazine put out by the State Planning and Development Commission, extolling the state's seasonal joys. Skiing was frequently depicted on the front cover and in articles during the winter months.

The New Hampshire
Troubadour
Christmas 1935

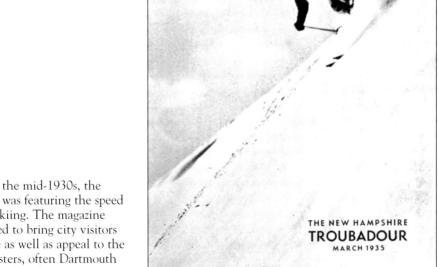

Already by the mid-1930s, the *Troubadour* was featuring the speed of Alpine skiing. The magazine was designed to bring city visitors to the state as well as appeal to the local speedsters, often Dartmouth collegians and graduates.

THE NEW HAMPSHIRE
TROUBADOUR
MARCH 1935

During World War II, the state continued to advertise skiing as one healthy recreation that would keep you "fit to fight." A view of the Taft trail provides the cover photograph.

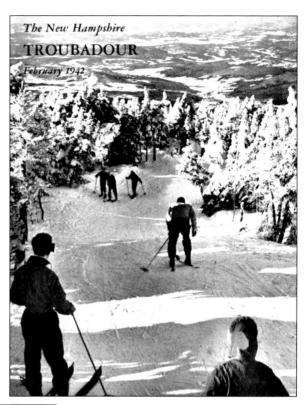

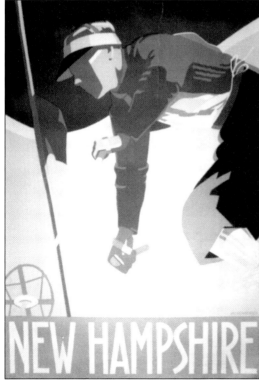

Stylized poster art by Hechenberger shows a slalom racer taking a gate in his best togs. Note that the flag is halfway down the pole.

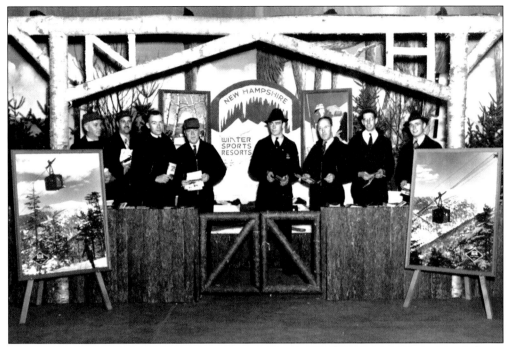

The state took its skiing pleasures to Boston's Sportsman's Show in 1938. New Hampshire's woodsy image was combined with its first-in-the-nation tram to advertise the rustic foundations upon which high-tech efficiency was built.

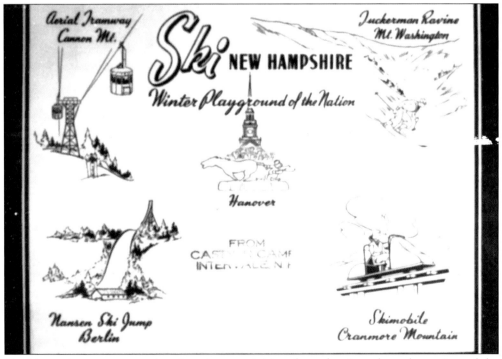

Aerial Tramway
Cannon Mt.

Ski NEW HAMPSHIRE
Winter Playground of the Nation

Tuckerman Ravine
Mt. Washington

Hanover

FROM
CASTLE IN CAMP
INTERVALE N H

Nansen Ski Jump
Berlin

Skimobile
Cranmore Mountain

Used by various groups to advertise winter activities, these drawings show the variety of the winter's attractions that might appeal to visitors in the late 1930s.

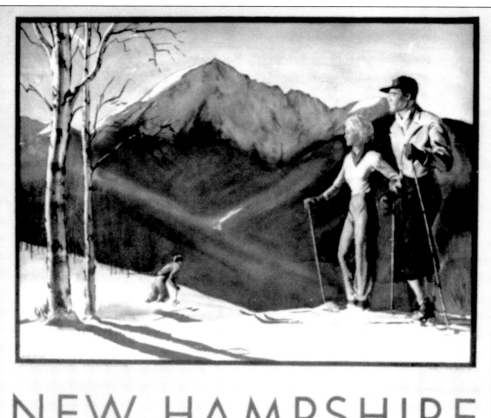

NEW HAMPSHIRE
Land of glorious winter

The best known of the posters promoting the state, Dwight Shepler's "Land of glorious winter" captures precisely the fresh outdoors freedom, the spectacular backdrop, along with the joys of social skiing to be found in New Hampshire in 1936.

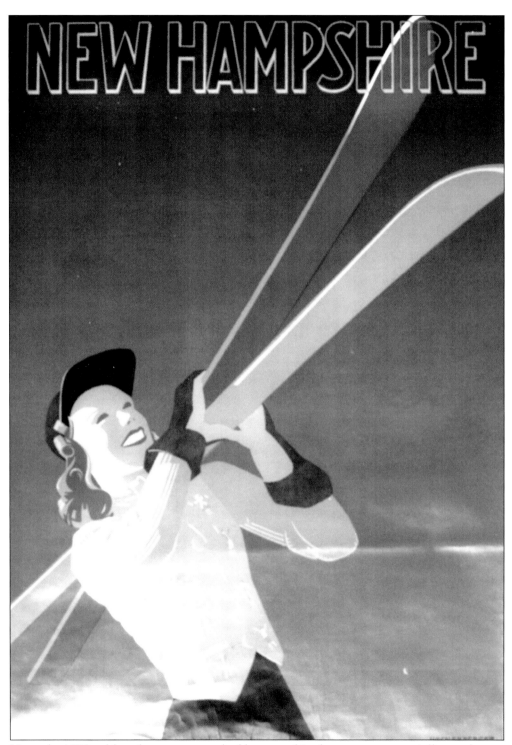

Up to the 1920s, although many women had been on skis, the sport was essentially a male one. In the 1930s, however, the social side of skiing became one of the attractions, and posters began to portray the sport as healthy and great fun for women too.

NEW HAMPSHIRE
Recreational Calendar
WINTER SEASON, 1943-1944

Issued by the State Planning and Development Commission, Concord, N. H.

While Dad might be at the front, Granddad initiates the youngest one into the thrills of speed.

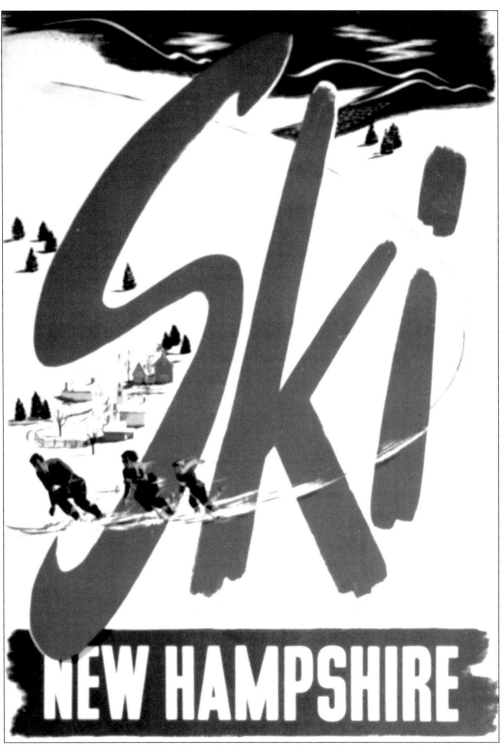

After the war, family skiing was promoted. The poster indicates the picture-perfect village with comfortable inns to return to after a day of speed and thrills for Dad, Mom, and Joey.

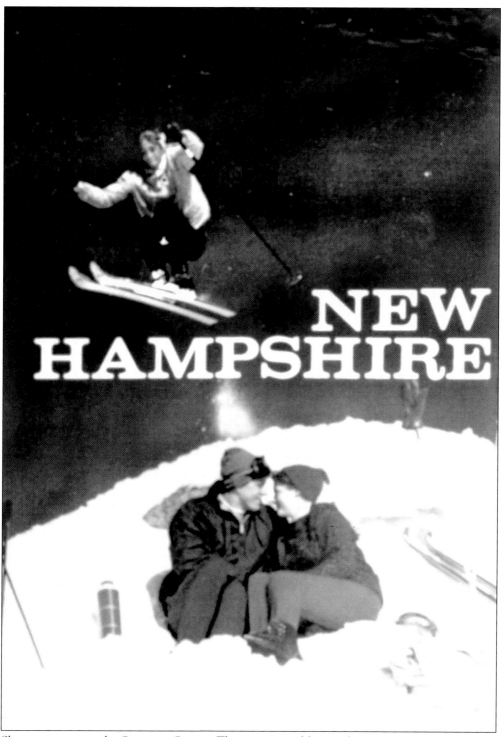

Skiing swings into the Swinging Sixties. This poster would never be concocted today; you just do not sit on the downside of a hill. This image was designed to bring tourists north both for expert skiing and fun in the snow and sun.

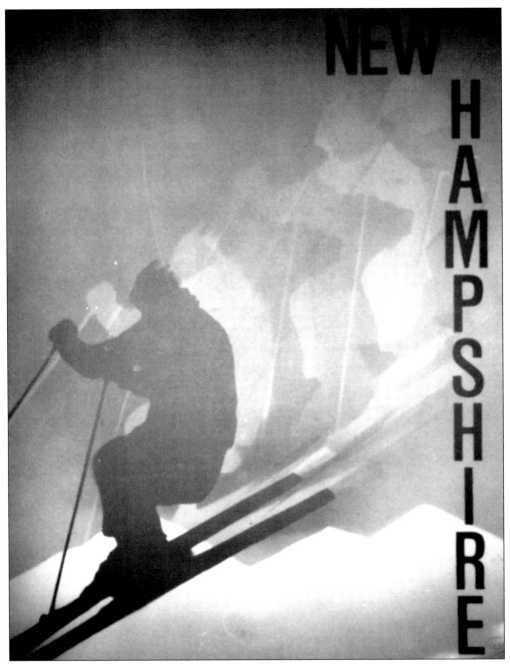

By 1989, the state's promotion of skiing had gone high-tech in both the depiction of the ski technique and the poster's imagery.

Two
SPORTING BEGINNINGS

Many tourist parties have enjoyed skiing and other sports.
—The *Littleton Courier*, February 16, 1911.

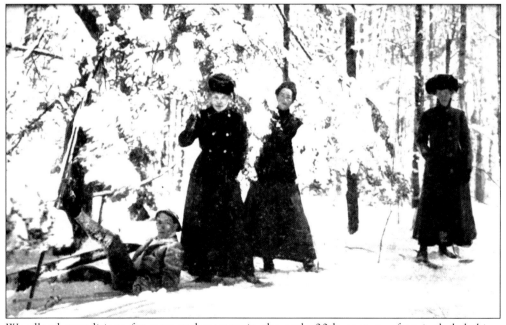

Woodland expeditions for men and women in the early 20th century often included skiers along with the more numerous folk on snowshoes.

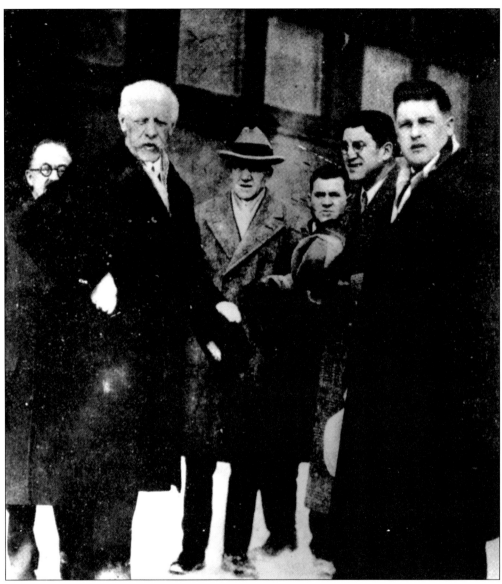

The most important early center for skiing in the state was Berlin. Norwegian immigrants formed a club, which came to be called the Nansen Club in honor of famous Norwegian explorer Dr. Fridtjof Nansen (second from left), seen arriving in Berlin in 1929. Forming the greeting committee are, from left to right, John Graf, Evan "Jack" Johnson, Councilman Ramsay, Mayor Dr. McGee, and Alf Halvorsen, who did so much to promote Berlin skiing.

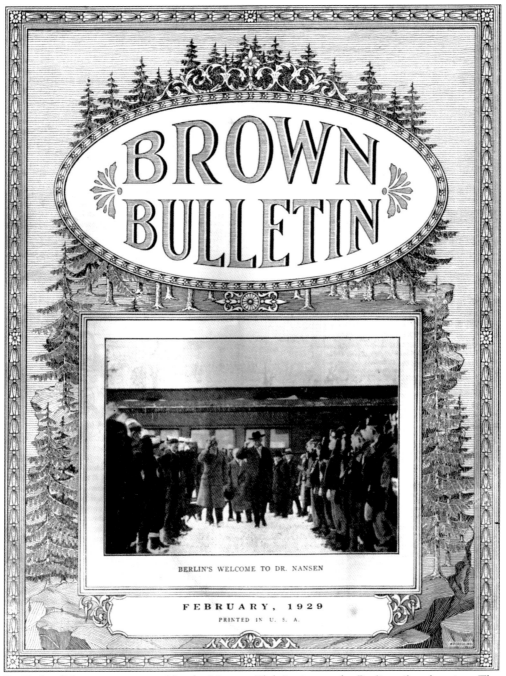

BROWN BULLETIN

BERLIN'S WELCOME TO DR. NANSEN

FEBRUARY, 1929

PRINTED IN U. S. A.

Dr. Fridtjof Nansen was greeted by the Nansen Club Juniors at the Berlin railroad station. The logging company's magazine made much of his visit in February 1929.

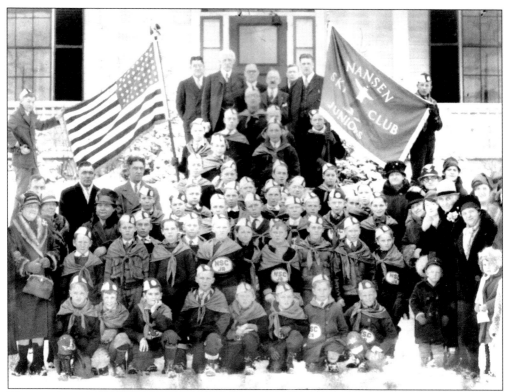

This is a formal picture of Dr. Fridtjof Nansen with the Nansen Club Juniors all wearing their club sweaters and hats.

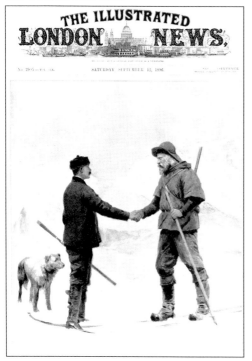

"We feared to see him lest his actual presence should dim the luster of his fame," wrote the *Brown Bulletin*. Nansen's fame rested on his crossing of Greenland on skis in 1888 and his attempt to reach the North Pole. For thousands perhaps millions of people, drawings such as the one here made visual the hero who had gone the farthest north and was, almost unbelievably, now in Berlin, New Hampshire.

Section 12 of the Constitution of the Nansen Club reflected its early ethnic exclusiveness, for "any Scandinavian of good reputation of 15 years living in Coos Country . . . will be accepted by majority vote." The good reputation was addressed in Section 13: "If a member comes to a regular meeting and is in a drunken condition, he cannot take part in the business of the meeting."

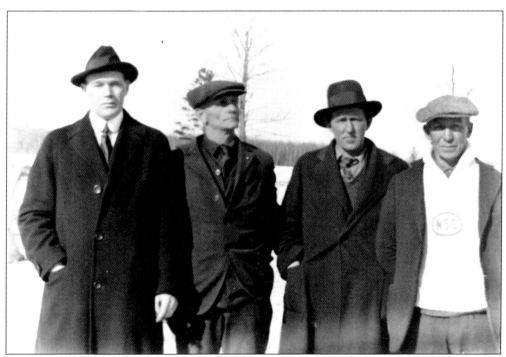

Four charter members of the Nansen Club pose in March 1925. They are, from left to right, Richard Christiansen, Iver Anderson, Eric Holt, and one of the best-known jumpers, Olaf "Spike" Olsen.

This 1925 record of the Berlin Winter Carnival illustrates the importance of jumping to the sporting community. Many small towns and communities in the state had jumps, but the Berlin jump remained the most prestigious in the state.

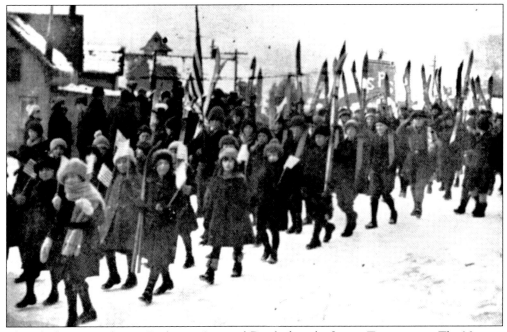

These kids are parading in Berlin on Carnival Day before the Junior Tournament. The Nansen Club took special care to promote skiing among children; the elders realized that the future of the club relied on bringing up the youngsters in the ski tradition.

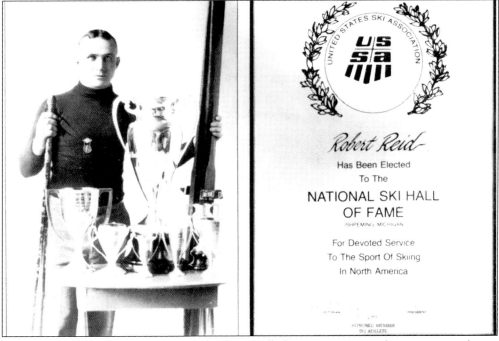

Robert Reid

Has Been Elected
To The

NATIONAL SKI HALL OF FAME

ISHPEMING, MICHIGAN

For Devoted Service
To The Sport Of Skiing
In North America

One of those youngsters was Bob Reid, who excelled in cross-country skiing. He was chosen to represent the United States (along with fellow club member Erling Andersen) in the 50-kilometer event at the 1932 Lake Placid Winter Olympics. He was elected to the National Ski Hall of Fame in 1975.

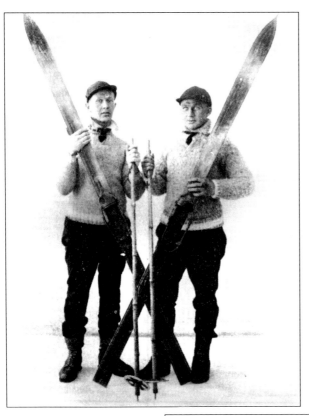

Bob Reid (right) and Helmer Oakerlund, both of the Nansen Club, were the only competitors in a 100-mile event from Portland, Maine, to Berlin in February 1926. The race was run over four days and was designed both to promote the Berlin Winter Carnival and to see if it would be feasible as an annual event. The weather decided that it was not.

This bib was worn by the two competitors for what became known as "100 Miles of Hell." After a delayed start caused by a storm, Oakerlund and Reid rested at Gray for four hours and arrived at Poland Spring at 12:20 a.m. for their first night. On the final day, they both left Bethel at 9:30 a.m., and Reid reached the city hall in Berlin at 3:37 p.m. with Oakerlund only eight minutes behind.

100 MILE SKI RUN, PORTLAND TO BERLIN.

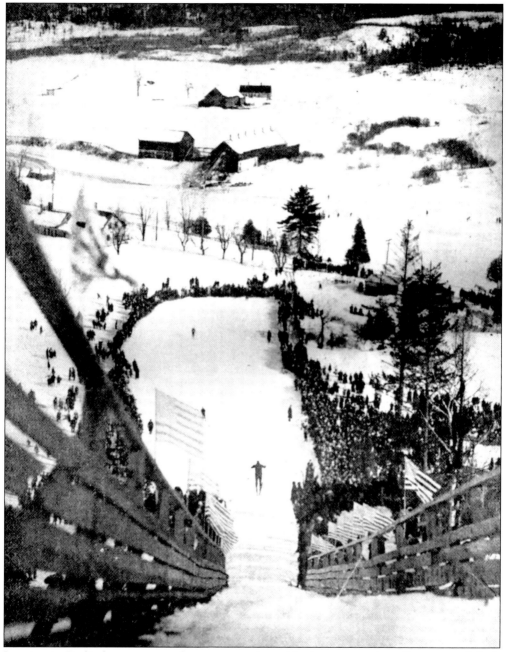

Jumping in Berlin became more than an attraction with the construction of a jump at Paine's Pasture, seen here in a photograph from 1923. In the 1920s, the jumpers were the stars of the skiing world, "knights of the air," and Bing Anderson was the best known.

THE NATIONAL SKIING WEEKLY

The SKI BULLETIN

Vol. IX No. 14 FEBRUARY 24, 1939 Price Ten Cents

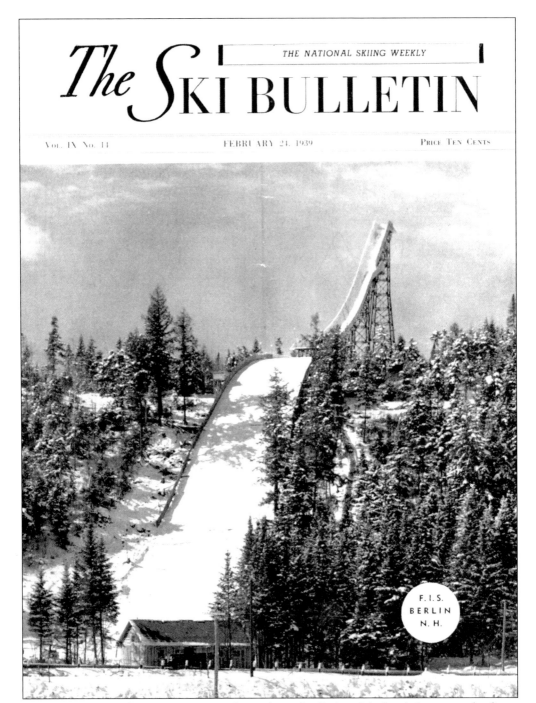

As Nansen jumpers became attractions themselves, the Berlin club decided to erect the finest jump in the East just north of the city on Milan Road. The structure stands in decay now, but there were days when men could fly over 270 feet off this famous landmark of New Hampshire, which, unfortunately, has not been put on the historic register.

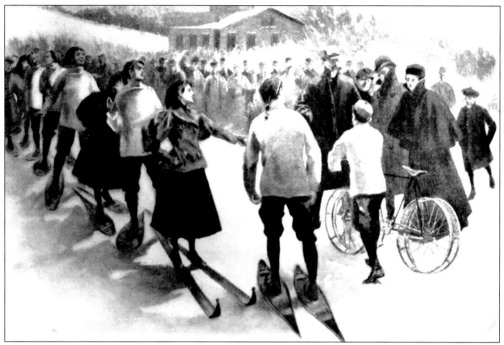

This is a school race in 1886. Note how high the tips of the skis are turned up. Skiing in those days often meant plowing through deep snows, and the high tips provided a way to cut a furrow.

1930 Eastern Amateur
SKI
CHAMPIONSHIP
and CARNIVAL

Friday Feb. 14	CLAREMONT New Hampshire	Saturday Feb. 15

THE
CLAREMONT OUTING CLUB

INVITES YOU TO JOIN IN THEIR WINTER
SPORTS IN THE RUGGED NEW HAMPSHIRE
HILL COUNTRY

FEBRUARY 14TH AND 15TH

High Lights of the 1930 Carnival

U. S. Eastern Amateur Ski Jumping Championship and Cross Country Race, Elaborate Carnival Ball, Mardi Gras, Skating, Tobogganing, Snowshoeing, Wood Sawing Contests, Dog Races, Straw Rides.

Forty years later, organized clubs were scattered all over the state. Claremont hosted the 1930 Eastern United States Championship with jumping and cross-country events along with carnival attractions of wood-sawing contests and straw rides (now hayrides). Every carnival ended with a ball.

Claremont Youngsters Enjoying Tobogganing on the Outing Club Slide

Dartmouth College in Hanover provided the venue for the first center for sporting skiing for the well-to-do. The Dartmouth Outing Club drew much of its early inspiration from immigrant skiing activities in Berlin and then gave them a collegiate ethos, such as this house party in 1913.

HANOVER is becoming famous as the New England centre for winter sports. Nowhere are they better organized. Here is a party of ski men out for the day. The Inn offers comfortable headquarters, winter and summer alike, and Dartmouth College should, of course, be visited

THE HANOVER INN *at* DARTMOUTH COLLEGE
HANOVER, NEW HAMPSHIRE

The Hanover Inn used Dartmouth men on skis to promote itself. Hanover was becoming known as a "New England center for winter sports," appealing to a broader winter clientele even before World War I.

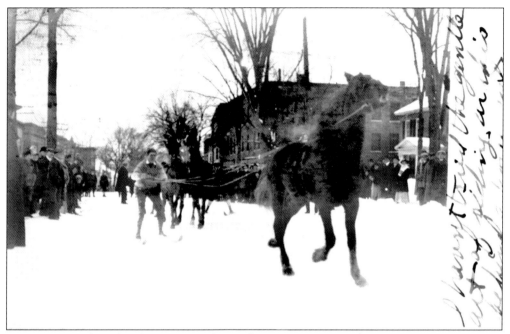

Winter Carnival weekend at Dartmouth was the great sporting and social event of the season. Besides cross-country and jumping, events such as skijoring around the Hanover common provided excitement for the guests in 1917.

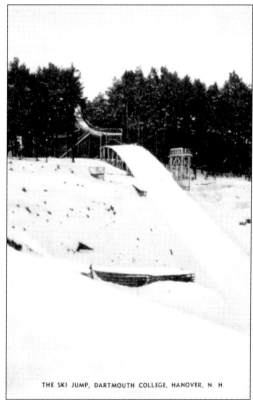

THE SKI JUMP, DARTMOUTH COLLEGE, HANOVER, N. H.

Compared to modern jumps, Dartmouth's slide does not look particularly impressive, but it provided the thrills (and spills) for intrepid Dartmouth men who vied for honors against the University of New Hampshire, Yale, Harvard, the University of Vermont, Middlebury College, and McGill University in the early days.

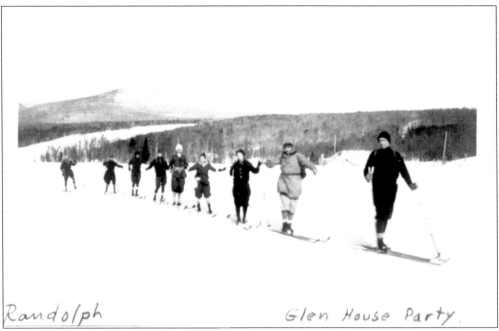

Randolph Glen House Party.

Graduates who had skied in their college years continued to enjoy the sport by joining clubs like the Appalachian Mountain Club (AMC) or formed their own parties to go to such places as Randolph and stay at the Glen House in 1926.

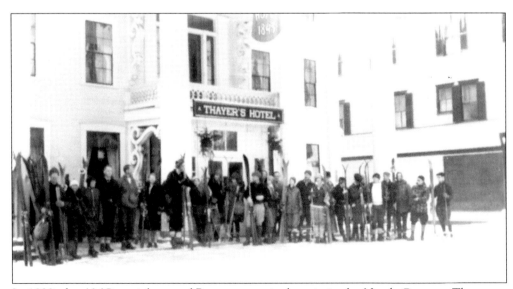

In 1929, the AMC, mainly out of Boston, organized a trip in the North Country. The group stayed at Thayer's Hotel in Littleton, one of the few hotels to remain open in the winter and capitalize on the new winter sports.

Three

DARTMOUTH SETS THE TONE

The proposal for founding the Dartmouth Outing Club finished with the following: By taking the initiative in this manner, Dartmouth might well become the originator of a branch of college organized sport hitherto undeveloped by American colleges.
—Fred Harris to the Dartmouth, December 7, 1909.

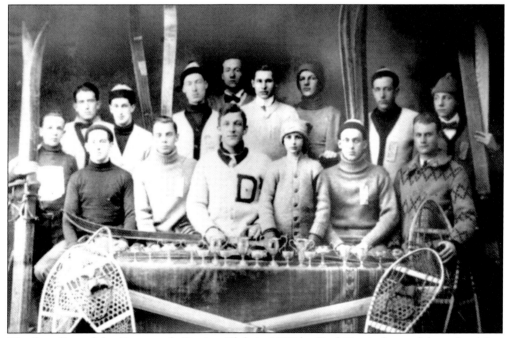

The founding of the Dartmouth Outing Club in 1909 by Fred Harris (center) brought skiing into the purview of the wealthier sectors of eastern society.

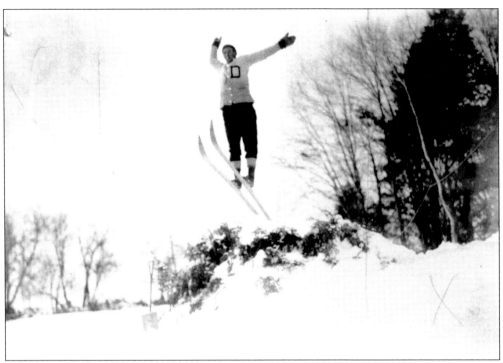

These two images depict jumping at Dartmouth about 15 years apart. In the top photograph, Fred Harris is traveling 40 feet over a homemade jump c. 1910, and in the mid-1920s, a crowd has turned out to watch the stars perform on the day of the Winter Carnival. From a carefully constructed jump with a packed runout, someone like Charley Proctor could fly more than 100 feet.

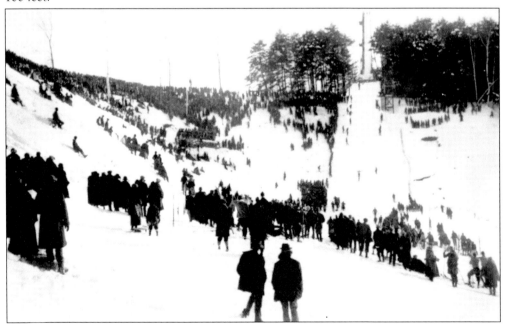

Downhill skiing was made far less exhausting with the invention of the rope tow in the early 1930s. The line for the tow on the Hanover golf course shows how popular it was. Today, of course, this area would be good only for cross-country, not downhill.

This undated carnival poster, possibly from 1932, shows how much the Alpine ethos had permeated skiing. Here, an expert racer in full racing gear and with superb technique (known as *Vorlage*) is flashing through a flagged course. No one at Dartmouth in 1932 would have looked quite like this.

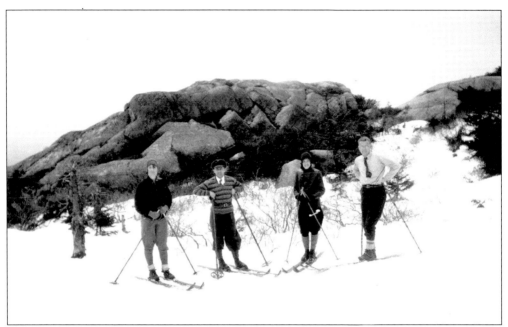

Looking as jaunty as ever, Otto Schniebs is taking a small group of "Appies" up (and down) Mount Monadnock in 1929. The AMC and Harvard University hired Schniebs as instructor while he was working at a watch factory.

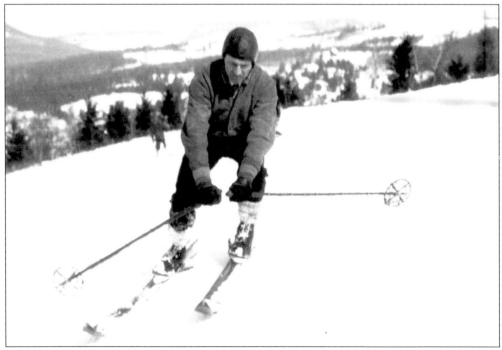

Otto Schniebs demonstrates the Alpine technique in 1929. He taught a regular weekly session to the AMC in the Boston area before being found by Dartmouth, where he came to coach both the team and locals in the mysteries of the Arlberg technique. "Favors Crouch Technique," reported the college paper, heralding Schniebs's arrival in Hanover.

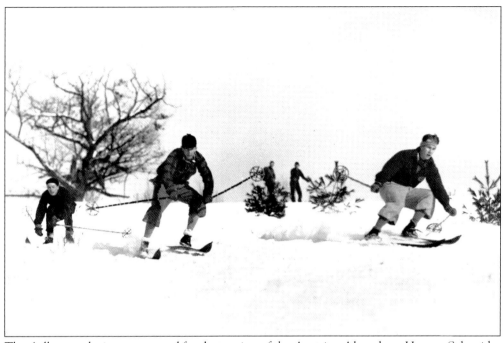

The Arlberg technique, so named for that region of the Austrian Alps where Hannes Schneider had perfected it, was essentially a low crouch with a lift and swing into the turn. Once their speed was up, skiers tended to stay in the crouched position.

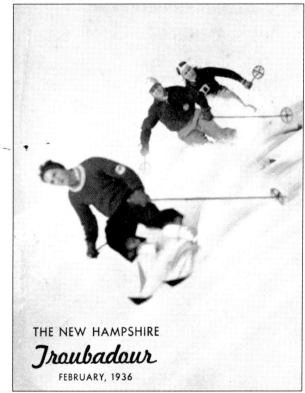

THE NEW HAMPSHIRE

Troubadour

FEBRUARY, 1936

By the mid-1930s, the Dartmouth team had the technique down. Led by Dick Durrance (in the lead here, followed by Ted Hunter and Sel Hannah), who had learned his skiing in Germany, Dartmouth skiers speed down the cover of the state's *Troubadour*.

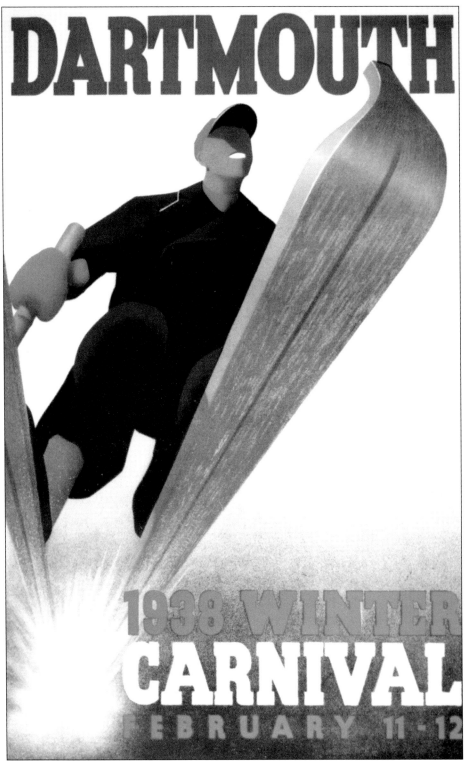

Strength, power, health, and Dartmouth are proclaimed here by poster artist Joanethis.

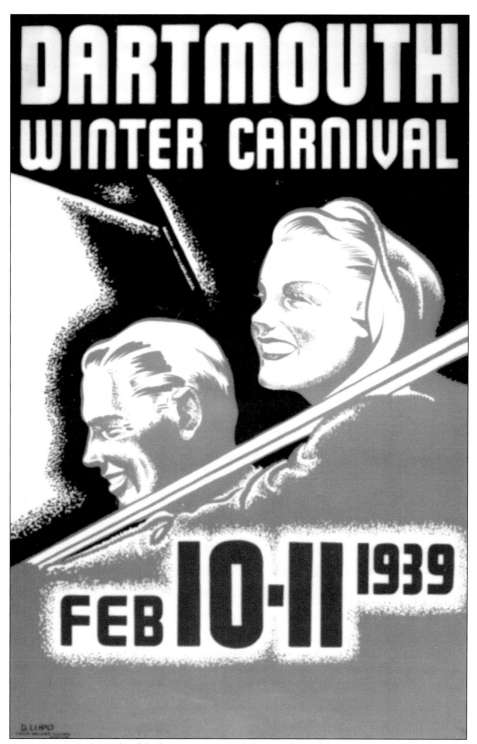

D. Lupo's poster portrays health, happiness, sociability, and good looks. In the 1930s, the Winter Carnival became a major social attraction, and many young women from Smith, Wellesley, and Mount Holyoke Colleges trained north for the winter weekend.

The finish of the first United States National Downhill Championship on March 12, 1933, is shown on Dartmouth's own Mount Moosilauke. Sixty-nine runners finished, and the winner was Dartmouth's Bem Woods, who ran the 2.8-mile Carriage Road in just over eight minutes.

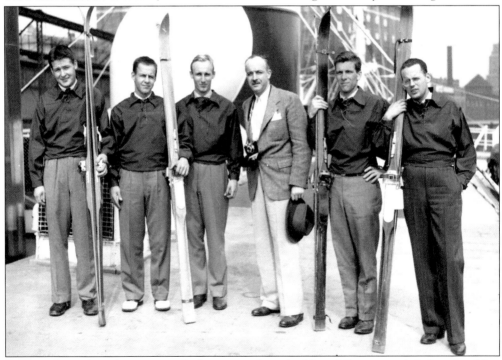

Dartmouth was heavily represented when teams from the United States traveled abroad to New Zealand and, in this photograph, to South America. Four of the five competitors were from Dartmouth. From left to right are Ed Wells, Don Fraser (the lone westerner), Steve Bradley, Eugene DuBois (organizer), unidentified, and John Litchfield.

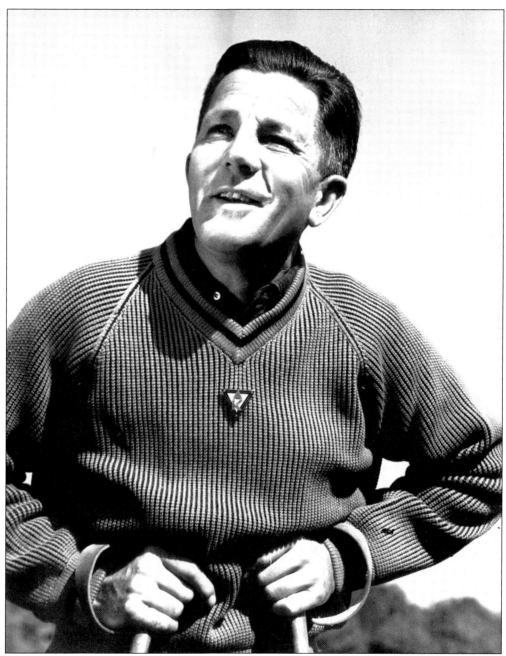

Swiss Walter Prager, winner of the Arlberg-Kandahar, the Parsenn, and other prestigious races in Europe, followed Otto Schniebs as coach for Dartmouth. He went on to join the 10th Mountain Division during the war and returned to Dartmouth to coach until 1957.

Howard Chivers (above) and John Litchfield (below) were two cross-country stalwarts of late-1930s Dartmouth teams and cocaptained the 1939 team. Chivers won the Canadian and American cross-country championships and was selected for the 1940 Olympic team. Litchfield, like Chivers, was selected for the 1940 U.S. Olympic squad, which never got to race because of the war. After joining the 10th Mountain Division, he opened the Red Onion in Aspen while teaching at the Aspen Ski School. Later, as executive director, he ran the Sun Valley ski school. He was inducted into the National Ski Hall of Fame in 2002.

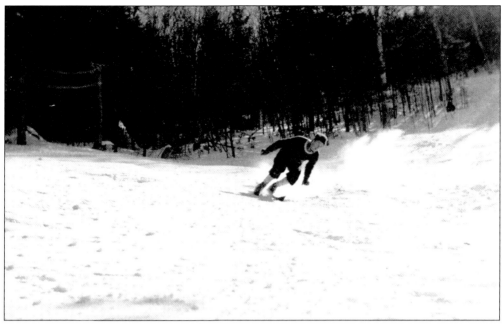

Dick Durrance carves a fast turn on the Wildcat. Durrance had been German junior champion before attending Newport High School and Dartmouth. He won many championships, including cross-country and jumping, but he was best known for his Alpine technique. He won 8th place in slalom and 11th in downhill at the 1936 Olympics. At home, he retired the Harriman award.

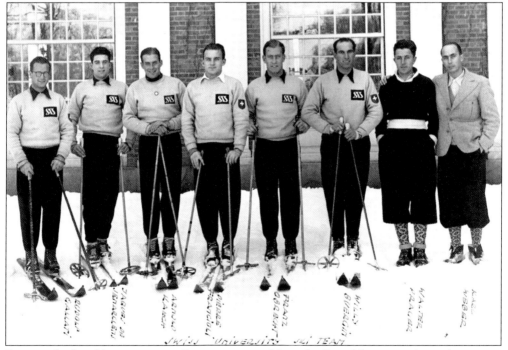

Dartmouth played host to visiting European teams. Here, the Swiss Universities' team lines up in Hanover along with the two coaches, Dartmouth's Walter Prager (also Swiss) and Karl Weber.

SKI
EQUIPMENT

THOMPSON
and
HOAGUE CO.

Concord

In the early days, people put on their winter outdoor clothes to go skiing. In the 1920s, riding gear such as jodhpurs was popular. It was only in the 1930s that shop owners realized there was a growing clientele who would buy specialized equipment and clothing. Thompson and Hoague of Concord provided special hats, sweaters, and plus four–type trousers for her and breeches for him.

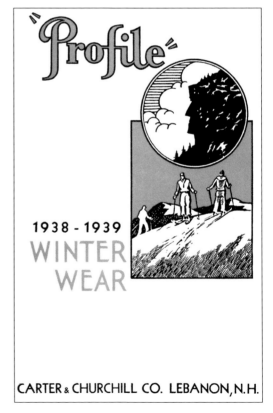

1938 - 1939
WINTER
WEAR

CARTER & CHURCHILL CO. LEBANON, N.H.

Carter and Churchill became one of the best-known ski clothing manufacturers in the United States.

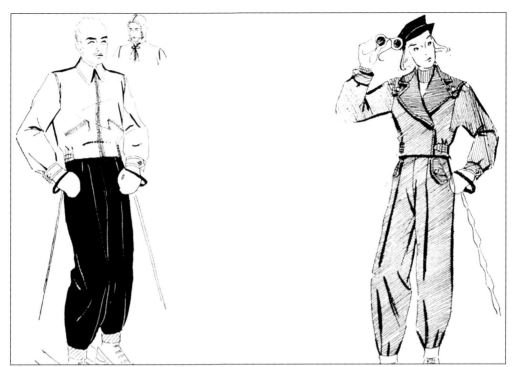

Profile's ski fashions for the 1938–1939 season included a windproof and water-repellent jacket with zippers. The *Vorlage* pants (using a German skiing term meaning "forward lean") were of gabardine. For her, an all-worsted gabardine ski suit was sold with either *Vorlage* or sateen-lined pants. Discreet color was the order of the day: navy, natural, or tan for him, and navy or gray for her.

There were ski shops in Boston in the late 1920s, and ski equipment and clothing were sold at other stores too. Carroll Reed was the first entrepreneur to bring the ski shop right to ski country while using the image of Benno Rybizka as the perfectly attired Austrian skier that Americans should emulate.

This advertisement shows a down-mountain skier using equipment tested by one of the well-known names of New Hampshire skiing, Walter Prager, skiing perhaps on Marius Eriksen skis. This shows the strong affiliation of excellence of ski equipment with the Norwegian heritage. Prager himself has given his imprimatur to bindings and boots. Switzerland and the Arlberg-Kandahar, such a well-known Alpine region and Alpine race by 1939, only add to the attraction of shopping for gear at the Dartmouth Co-op.

When wooden skis warped and the camber went out of them over a summer, a press like Oscar Cyr's that kept tails together and tips apart was a necessity. A blocking system at mid-ski prevented the loss of camber. As the advertisement implies, there were a number of such presses on the market.

Four

SKIING BECOMES MECHANIZED

The Winter Sports Club of Lisbon have cleared an 800 foot slope with a 200 foot vertical. Lisbon has raised the funds for a ski tow and intends that with this completed all the skier will have to do is ski down the trail—the ski tow will do the rest.
—Ski Bulletin, December 28, 1934.

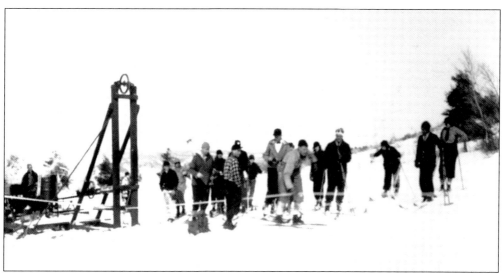

Ted Cooke's tow is shown here at Mount Rowe (near Gunstock). Rope tows were inexpensive and inefficient at the start, but they were easy to put up. They did, however, provide the answer for instant uphill transportation from 1935 on all over the state.

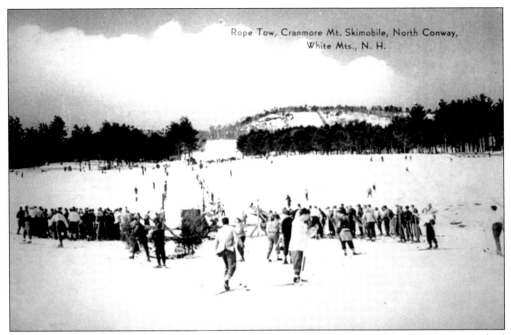

Rope tows, such as this one at Cranmore, often served the easiest slopes. Many people had trouble holding on to an increasingly heavy rope that twisted. No wonder rope-tow grippers were invented.

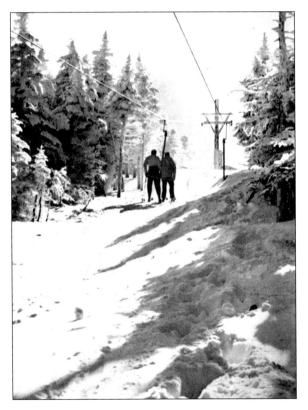

The T-bar, in the early days known as the "he-and-she-stick," provided a sociable ride up the mountain for skiers while being comparatively cheap for the ski area operator. This one was at Cannon.

Just like the early rope tows, the first T-bars were made with wooden frames. Patrons had to be instructed how to ride them: "Don't sit! Lean!"

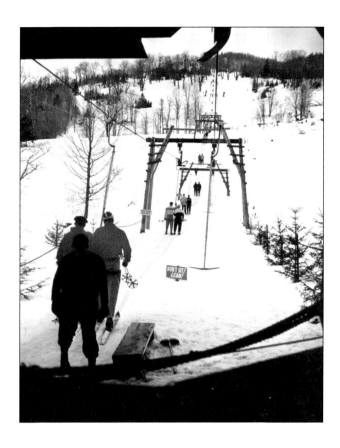

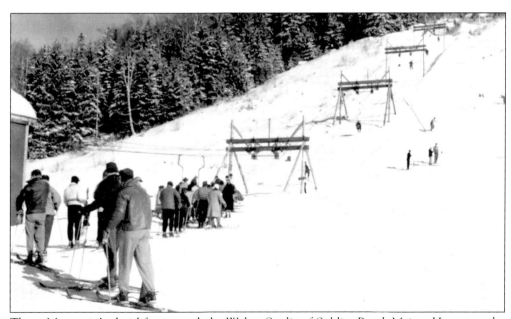

Thorn Mountain's chairlift was made by Walter Stadig of Soldier Pond, Maine. Here, too, the stanchions are from wood.

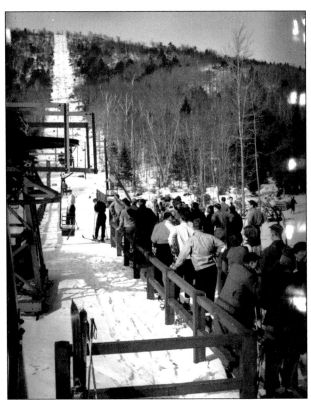

Belknap Recreation Area's chair tow was in business in January 1938. It was the second in the nation and proved very popular but was comparatively expensive to erect.

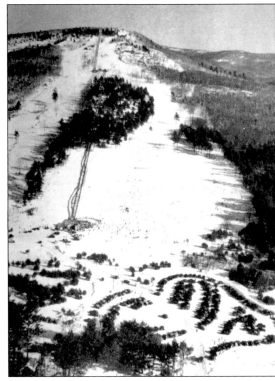

Cranmore's unique snowmobile also saw service first in 1938 and lasted until 1989. This is a view of the area in 1941. One of the original cars of the snowmobile sits just outside the front door of the New England Ski Museum.

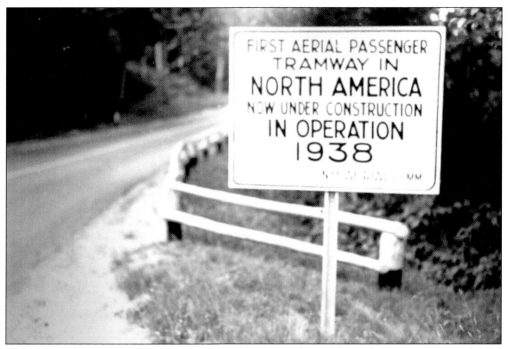

The sign on the road north to Cannon Mountain created excitement for visitors waiting for the new marvel of the tram—quite common in Europe—to be in operation in the United States.

These are two sketches of the proposed Cannon Tram buildings. The lower terminal held a waiting room, soda fountain, rest rooms, ticket counter, and manager's office. The upper terminal contained a writing and reading room besides providing storage space for deck chairs. Summer thoughts were in the designers' heads rather than winter practicalities.

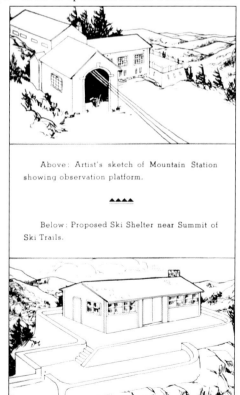

Above: Artist's sketch of Mountain Station showing observation platform.

▲▲▲▲

Below: Proposed Ski Shelter near Summit of Ski Trails.

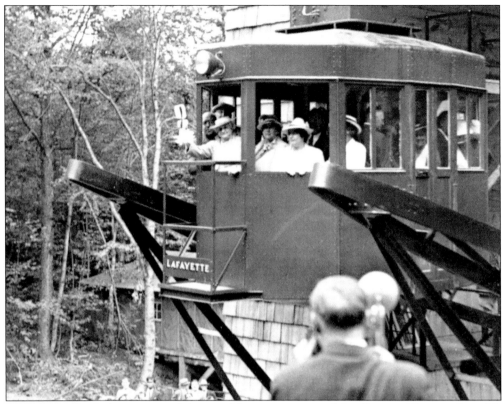

Christening the *Lafayette*, one of the two 20-passenger cars of the Cannon Tram on June 28, 1938, is Mae Murphy, wife of the governor of New Hampshire, Francis P. Murphy.

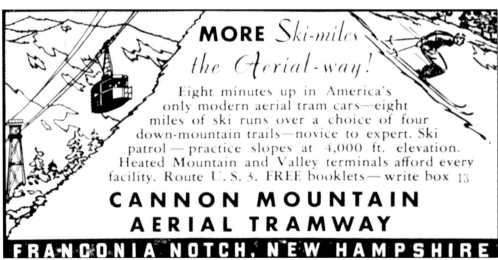

MORE *Ski-miles* *the* \mathcal{A}*erial-way!*

Eight minutes up in America's only modern aerial tram cars—eight miles of ski runs over a choice of four down-mountain trails—novice to expert. Ski patrol — practice slopes at 4,000 ft. elevation. Heated Mountain and Valley terminals afford every facility. Route U. S. 3. FREE booklets — write box 13

CANNON MOUNTAIN AERIAL TRAMWAY

FRANCONIA NOTCH, NEW HAMPSHIRE

The great appeal of the tram was that it covered close to 2,000 vertical feet in only eight minutes to the top of Cannon. Prior to the tram, you could expect to get only two or possibly three runs in a day.

The SKI BULLETIN

THE NATIONAL SKIING WEEKLY

Vol. IX No. 7 JANUARY 6, 1939 PRICE TEN CENTS

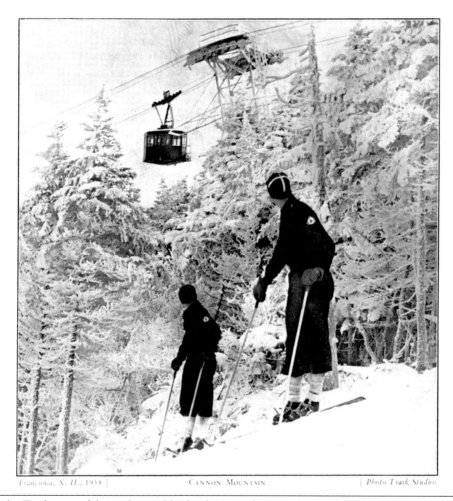

Franconia, N. H., 1938 CANNON MOUNTAIN Photo Trask Studios

Charles Trask, one of the early notable ski photographers, took this photograph at the beginning of the first winter of the tram's operation.

55

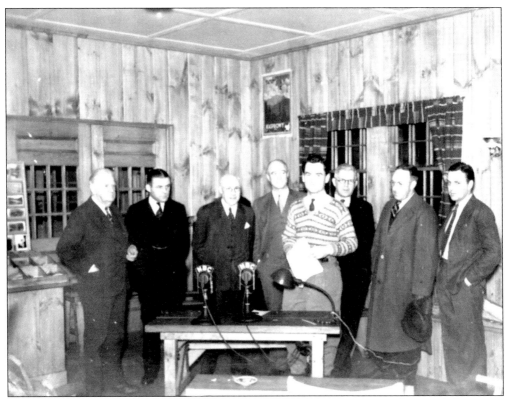

Famed broadcaster Lowell Thomas, here depicted at Cannon Mountain, advertised skiing as a sport on NBC radio. He made much of the ski center from which he was broadcasting, told a little of its history, and what fun and joy there was to be had sporting on the snow.

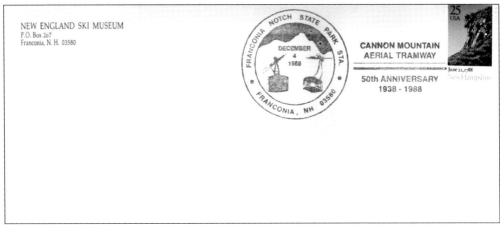

The New England Ski Museum, guardian of the state's skiing heritage, used this special postmark on the tram's 50th anniversary, along with the Old Man on the Mountain stamp on the 200th anniversary of New Hampshire's ratification of the Constitution of the United States, to send out its message as a real heritage keeper.

After 42 years and about six-and-a-half million passengers, the original tramway was retired (one of the cabins is now located at the entry of the New England Ski Museum), and the new 70-capacity tram took over in 1980.

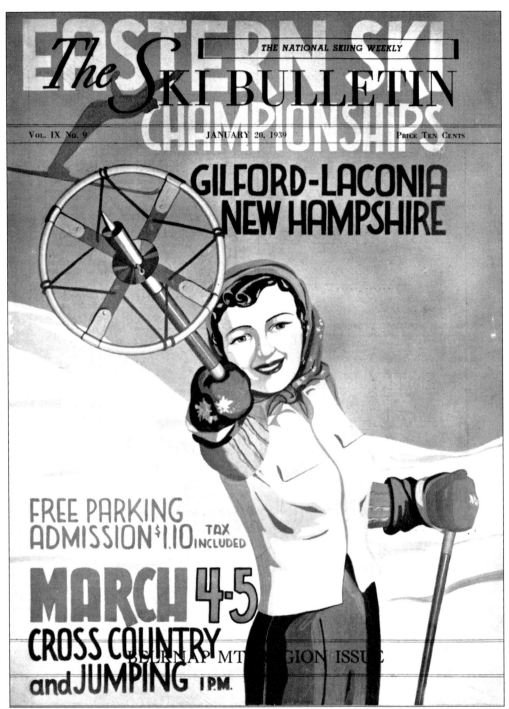

The *Ski Bulletin* was the AMC's informative information issued weekly. The Eastern Ski Championships in 1939 at the Belknap Recreation Area were, in fact, only for cross-country and jumping, yet the woman advertising the meet is dressed for recreational Alpine skiing. Alpine events were held at Stowe.

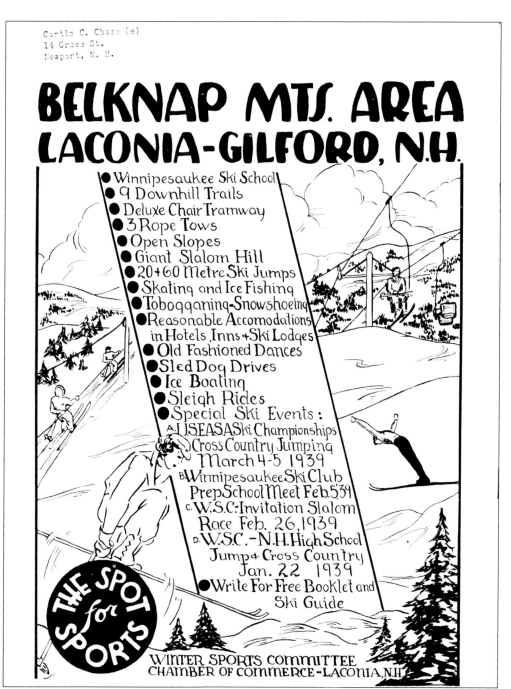

BELKNAP MTS. AREA
LACONIA-GILFORD, N.H.

- Winnipesaukee Ski School
- 9 Downhill Trails
- Deluxe Chair Tramway
- 3 Rope Tows
- Open Slopes
- Giant Slalom Hill
- 20+60 Metre Ski Jumps
- Skating and Ice Fishing
- Tobogganing-Snowshoeing
- Reasonable Accomodations in Hotels, Inns + Ski Lodges
- Old Fashioned Dances
- Sled Dog Drives
- Ice Boating
- Sleigh Rides
- Special Ski Events:
 A. USEASA Ski Championships Cross Country Jumping March 4-5 1939
 B. Winnipesaukee Ski Club PrepSchool Meet Feb. 5 39
 C. W.S.C.-Invitation Slalom Race Feb. 26, 1939
 D. W.S.C.-N.H. High School Jump + Cross Country Jan. 22 1939
- Write For Free Booklet and Ski Guide

THE SPOT for SPORTS

WINTER SPORTS COMMITTEE
CHAMBER OF COMMERCE-LACONIA, N.H.

This listing of what was available in the Laconia-Gilford region gives a good idea of just how important winter tourism had become by 1939.

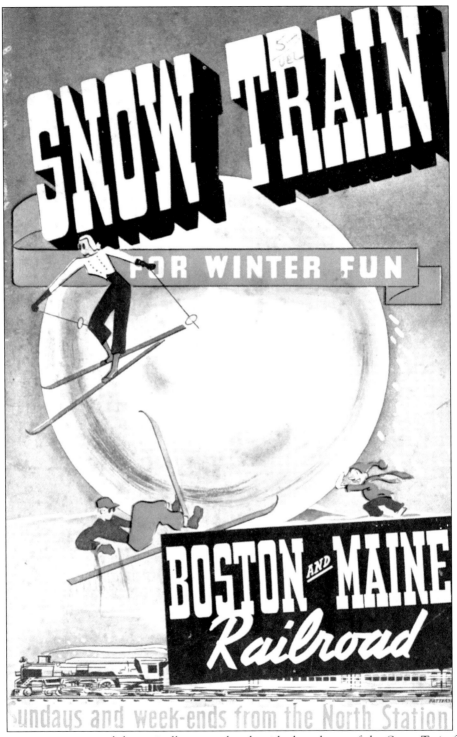

Winter tourism increased dramatically on weekends with the advent of the Snow Train from Boston's North Station. Organized by the AMC and the Dartmouth Outing Club of Boston, the first train carried 197 sports to Warner on January 11, 1931.

The Snow Train was a regular winter weekend phenomenon from 1931 to World War II, first from Boston and then from New York City. Advertising paid off for towns and hotels near ski destinations along the line north.

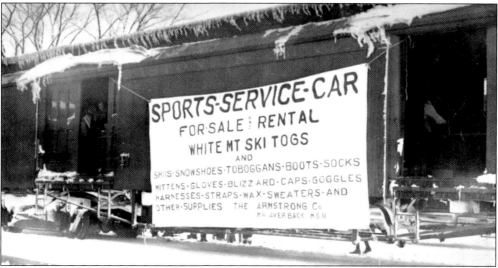

The Snow Train itself soon became something other than mere transportation. You could walk off the street in Boston and be fully equipped by the time you reached New Hampshire's hills, sometimes even signed up with a ski instructor who was already aboard.

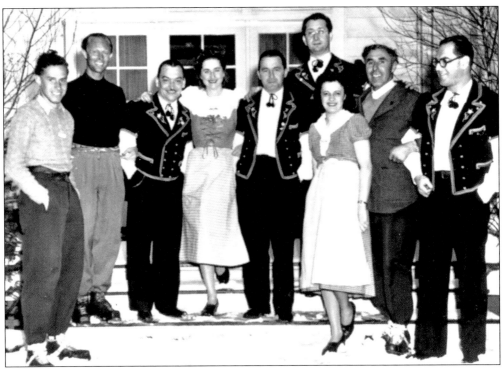

Evening fun was provided at the Eastern Slope Inn by Charlie Zumstein's authentic Austrian orchestra. They are shown here flanked by famous instructors young Herbert Schneider and Benno Rybizka, and second from the right is Hannes Schneider.

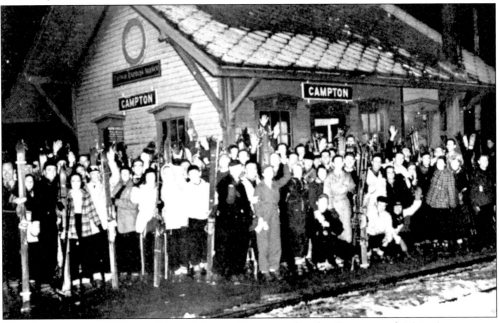

This happy and weary crowd is waiting at Campton for the Boston and Maine's return to Boston. With wartime gasoline rationing, the railroad gave many skiers the chance to play in New Hampshire's hills.

Increasingly in the 1930s, more winter enthusiasts came north in their cars. The state kept Pinkham and Franconia Notches open from 1926 on.

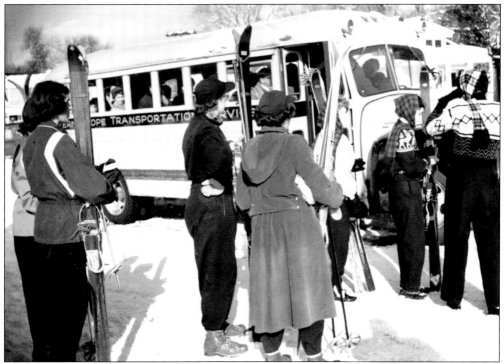

Once at the North Conway station, visitors would be taken to Jackson or Cranmore Mountain by buses of the Eastern Slope Transportation Service.

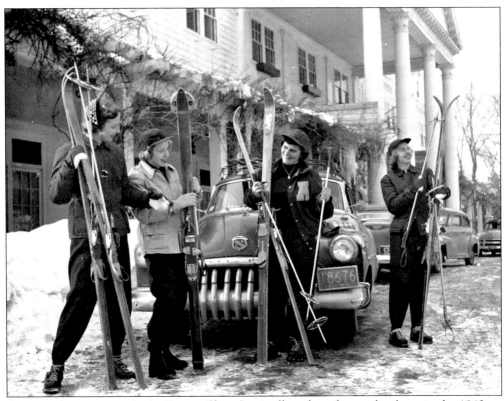

A group of women outside the Eastern Slope Inn is all set for a day on the slopes in the 1940s.

The New Hampshire Troubadour
December 1947

Ski racks were often personal inventions in the 1930s. A decade later, manufacturers saw a market and produced side racks, overhead carriers, and these contraptions for the backs of cars.

Five

New Hampshire Takes to Ski Instruction

Charley Proctor had selected with nice eclecticism the particular virtues of Arlberg, Bilgeri and Wengen methods, and grafting them on sound Scandinavian tradition, he has given us a technique modified and adapted to our American terrain.
 —Park Carpenter in the introduction to Proctor's *Ski-ing*, 1932.

The new city clientele did not know how to ski. Ski instruction became a new profession. This 1936 notice is touting would-be ski instructors.

The Marquis degli Albizzi, dapper and an excellent skier, was a resident instructor at Peckett's in Sugar Hill for a year in the early 1930s. Half Russian, half Italian, he was a teller of tall tales from World War I and beyond.

Kurt Thalhammer and Sig Buchmayr, both Austrians, enlivened Peckett's skiing and social life. Peckett's Inn not only had its own instructors in the 1929–1930 season, but it also offered instruction to others, thus securing the title of America's first ski school.

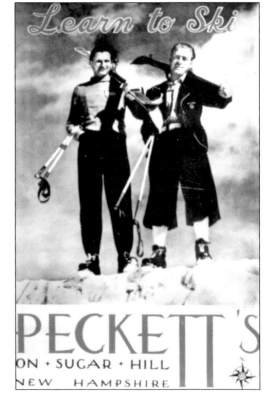

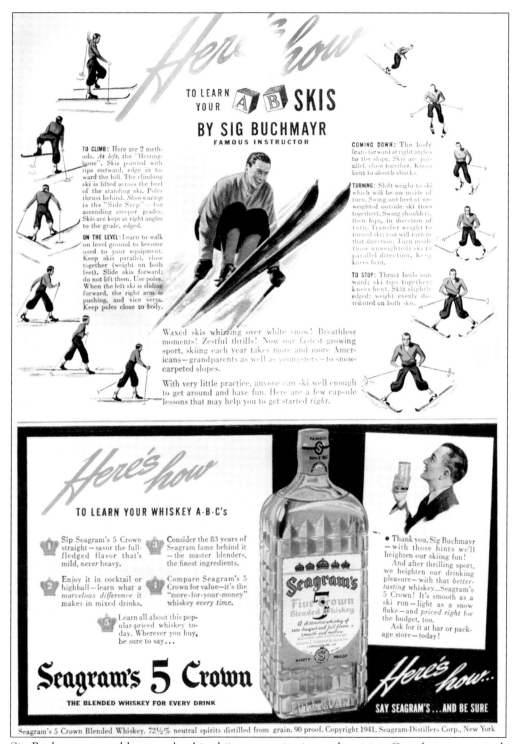

Sig Buchmayr was able to parlay his skiing expertise into advertising Camel cigarettes and, here, Seagram's whiskey. Frequently, the advertisements would offer mini-instruction before the smoke or drink, which would refresh and revivify.

If Sig Buchmayr was the more social host at Peckett's, Kurt Thalhammer did much of the teaching. Here, he is showing fine style in the heavy March snow of 1937.

Buchmayr is on course on the Richard Taft trail at Cannon. After many lessons at Peckett's, classes were transported to Cannon, and the experts would follow Buchmayr down the Richard Taft trail. The trail was started by Katherine Peckett in 1932 and finished with Civilian Conservation Corps (CCC) labor the following year. It became New Hampshire's and New England's premier race trail.

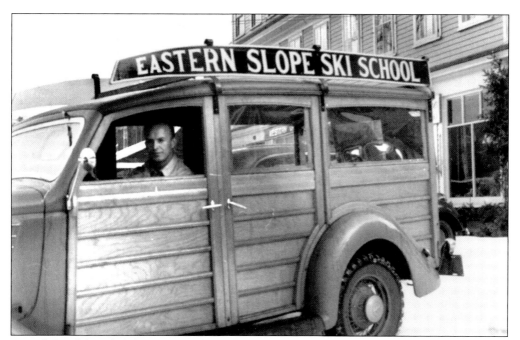

Carroll Reed founded the Eastern Slope Ski School not knowing much about ski instruction. He did know enough to import Austrians from Hannes Schneider's school, and Benno Rybizka soon trained some local lads as instructors.

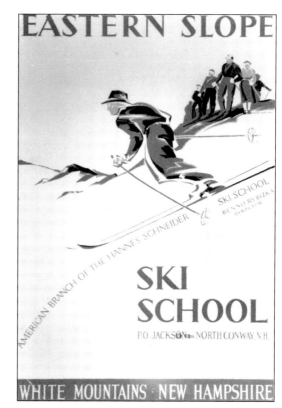

Arlberg purity was guarded by Benno Rybizka, who ran the Eastern Slope Ski School with iron discipline and a passion for flawless excellence. You were not allowed to do a stem turn until your snowplow was perfect.

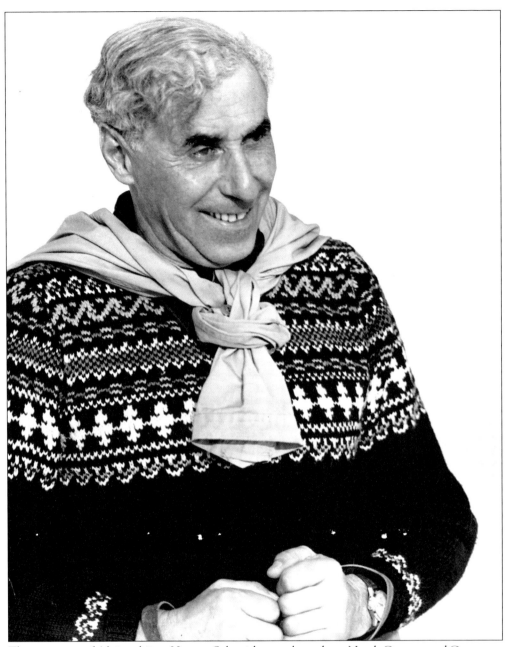

The great man of Alpine skiing, Hannes Schneider, was brought to North Conway and Cranmore Mountain by Harvey Dow Gibson after months of negotiation and financial arrangements with the Nazis. The Austrian Nazis put Schneider in prison the day of the Anschluss in March 1938, but he was released to a form of house arrest in Garmisch-Partenkirchen from where he was permitted to leave for the United States with his family.

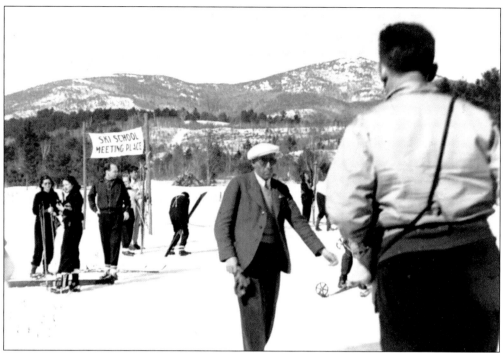

Hannes Schneider is at work here. He took over the ski school from Rybizka for the 1939–1940 season. Retaining his tie and jacket with an angled European cap, Schneider ran the ski school until his death in 1955. In later years, he took to American clothing. Here, he surveys a student's snowplow.

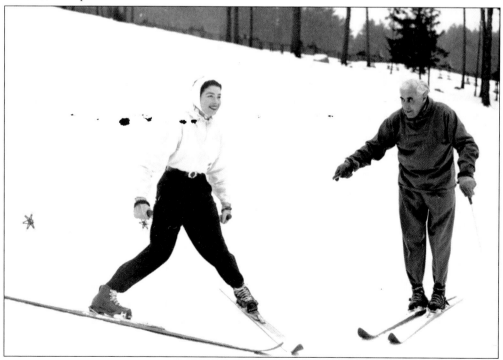

Benno Rybizka demonstrates perfect form. Rybizka came to head Carroll Reed's Eastern Slope Ski School at the American branch of the Hannes Schneider Ski School in 1936, just as Otto Lang—another of Schneider's protégés—did in the west. This is one major reason why the Arlberg technique was so entrenched in American ski instruction.

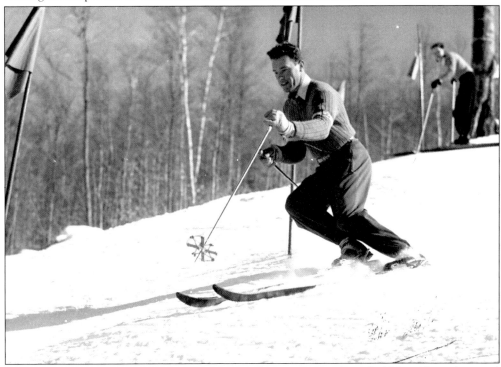

Toni Matt, another St. Anton Arlberger, arrived in 1939. He electrified New Hampshire and New England by winning 11 downhill contests in one season. Here, he is showing his slalom form in 1946.

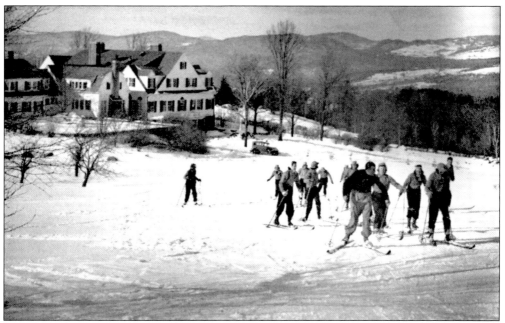

Schneider and his instructors gave lessons at local schools such as Freyburg Academy. The girls from St. Mary's, in the mountains near Littleton, also enjoyed Arlberg instruction on school grounds.

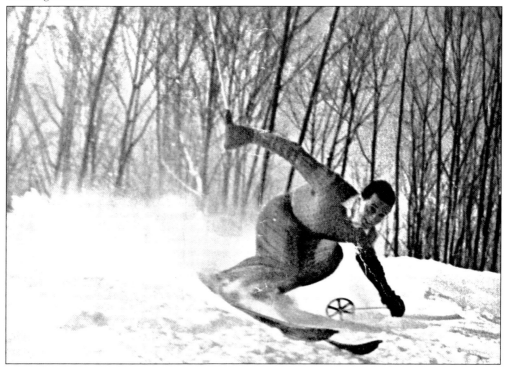

Wendelin Hilty, a Swiss who trained the Chilean army in the early 1930s, ran Wendy's Plymouth Ski School with his distinctive swooping style. Just to be Swiss or Austrian implied skiing credentials with which no American-born skier could compete.

The United States
Eastern Amateur Ski Association

takes pleasure in announcing that the following Ski Instructors have taken and passed the examination given for the Certification of Ski Teachers:

KARL ACKER, Pico Ski School, Rutland, Vt.
HARRIETTE AULL, Director of Skiing, Smith College, Northampton, Mass.
ARTHUR CALLON, Eastern Slope Ski School, Jackson, N. H.
OSCAR CYR, Newfound Region Ski School, Bristol, N. H.
ARTHUR DOUCETTE, Eastern Slope Ski School, Jackson, N. H.
JACK DURRANCE, Dartmouth Outing Club, Hanover N. H.
MICHL. FEUERSINGER, Pecketts-on-Sugar-Hill, N. H.
MARSHALL FITZGERALD, Hanover Inn, Hanover, N. H.
PETER GABRIEL, Franconia Swiss Ski School, Franconia, N. H.
JAUDRY JARDINE, Eastern Slope Ski School, Jackson, N. H.
FRANZ KOESSLER, Eastern Slope Ski School, Jackson, N. H.
ROBERT MORRELL, Eastern Slope Ski School, Jackson, N. H.
DAVID PARSONS, Manchester, Vt.
HERTA RICHTER-BERGMANN, New York City.
OTTO TSCHOL, Eastern Slope Ski School, Jackson, N. H.
MAURICE WILLEY, Eastern Slope Ski School, Jackson, N. H.

In addition, the following hold their certificates from last year:

SIG BUCHMAYR, Franconia (N. H.) and Woodstock (Vt.) Ski School.
EDI EULLER, Stowe, Vt.
JOHN HOLDEN, Putney School, Putney, Vt.
FRED NACHBAUR, Winnipesaukee Ski School, Gilford, N. H.
ROLAND PEABODY, Franconia Ski School, Franconia, N. H.
WALTER PRAGER, Dartmouth Outing Club, Hanover, N. H.
CHARLES PROCTOR, Boston, Mass.
SEPP RUSCHP, Stowe, Vt.
BENNO RYBIZKA, Eastern Slope Ski School, Jackson, N. H.
ARTHUR SCHLATTER, Coach, Middlebury College, Middlebury, Vt.
HANS THORNER, Mt. Washington Ski School, Glen House, Gorham, N. H.

Run your eye down this list and you will soon note how New Hampshire dominated the ski-instructional scene in 1938 after the second ski instructors' certification. Note, too, that 10 of the successful candidates were Americans.

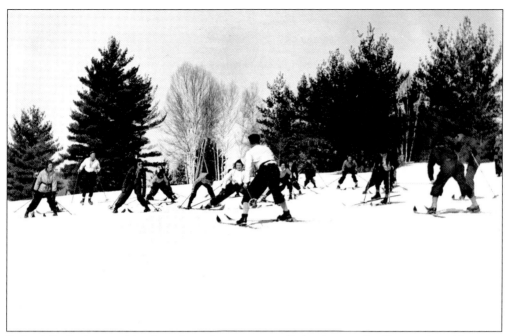

Roland Peabody puts his class through warm-up calisthenics on the Franconia golf course. Sometimes instructors were thought of and even advertised as trainers.

Peter Gabriel was a Swiss ski-school instructor in Franconia. He is posing with two guests of Lovett's Inn, where he was hired as a private instructor.

75

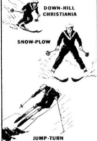
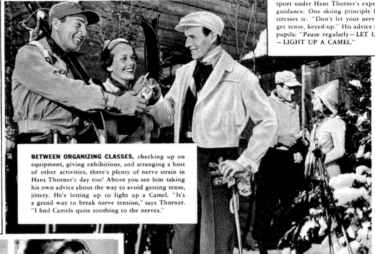

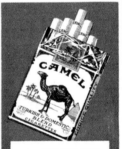
Hans Thorner is soothing his nerves "with a Camel cigarette after divulging the secrets of expert skiing." Thorner operated out of Franconia and then ran the Mount Washington Ski School. He went on to make skiing films and later opened Magic Mountain in Vermont.

Six

POST–WORLD WAR II: BUILDING SKI AREAS

Loon Mt. Ski Development Has Gratifying Beginning.
Waterville Valley Resort is $2.6 Million Development.
—Two headlines in the *Littleton Courier*, January 19, 1967.

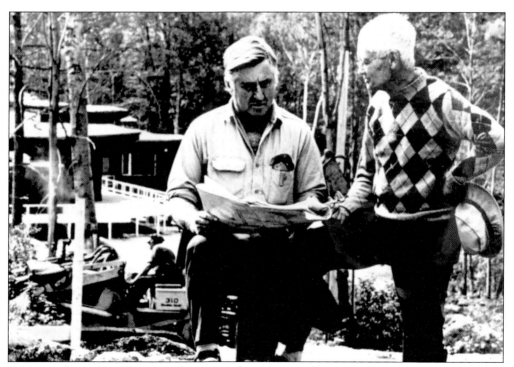

Sel Hannah, trail builder, and Sherman Adams, owner, discuss the layout of Loon Mountain in Lincoln.

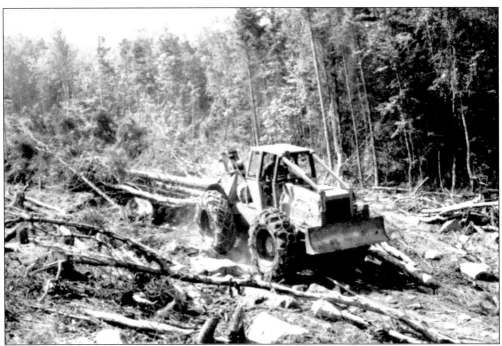

After World War II, large amounts of capital were poured into the development of ski areas. The 1930s ski center gave way to the modern recreational area. Large pipes are being laid for massive snowmaking, and trails are being cleared by heavy equipment. The days of CCC labor with a pick and shovel are long gone.

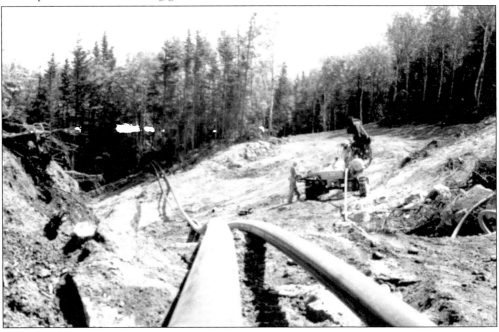

Loon hired helicopters to do what used to be done by men or oxen. The New England Ski Museum holds a short film about tow making in 1935. It shows oxen hauling up a rope while men raise a wooden stanchion by muscle power. What a difference modern technology makes.

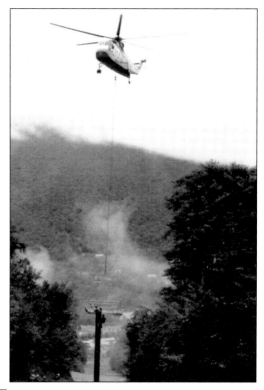

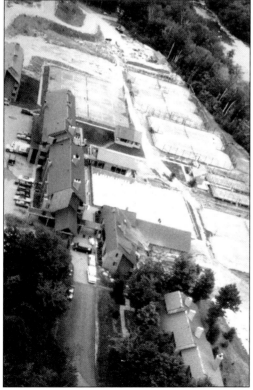

The ski area is no longer just for skiing. With the building of condominiums, the area has a captive clientele that needs year-round entertainment—hence, swimming pools, tennis courts, and golf courses are provided for summer fun.

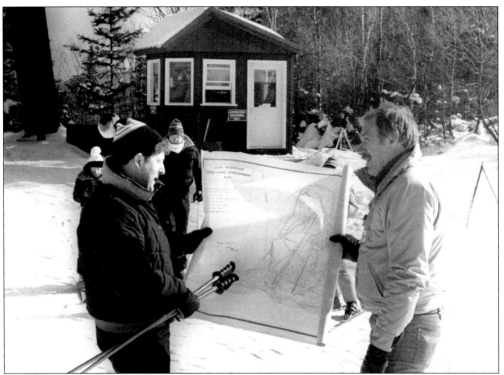

Gov. John Sununu (left) took much interest in the development of skiing in the state due to the increasing revenues brought in by winter tourism that swelled the state's pockets. He is talking to Phil Gravink, general manager of Loon Mountain.

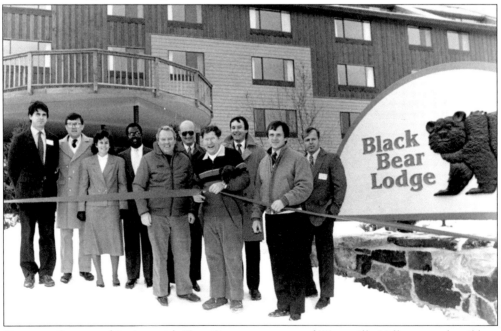

Governor Sununu, this time with Tom Corcoran, owner of Waterville Valley, cuts the ribbon at the opening of the Black Bear Lodge.

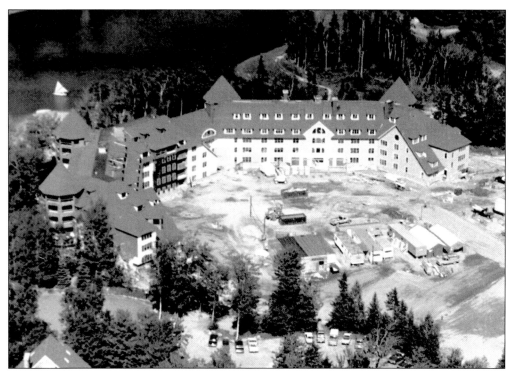

Waterville Valley, once a small ski area, became a real-estate development under Olympian Tom Corcoran. The Golden Eagle was designed with 139 units much like, according to the press release, the grand hotels of earlier in the century.

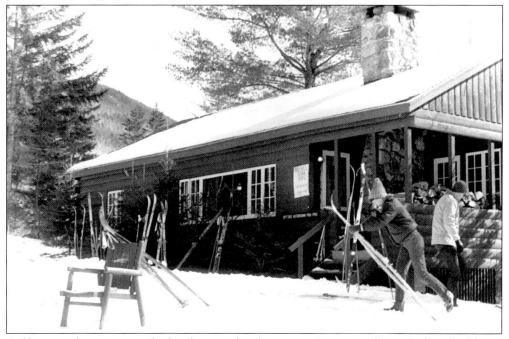

Golf courses became typical of real-estate developments. In winter, the pro's shop doubles as the cross-country center at Waterville.

Mittersill in Franconia, built by Austrian Baron von Pantz, re-created the ambience of an Austrian ski village. Mittersill closed in the 1980s, but there has been much discussion about its annexation to Cannon Mountain.

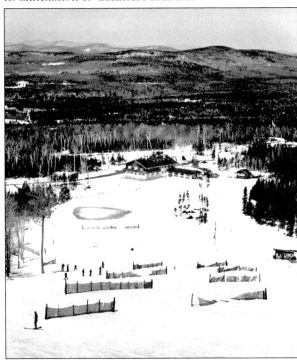

This is a view every downhill skier knows. Snow fences across a trail slow down the schuss boomers.

Snowmaking first became available commercially in 1952. Areas now boast of the percentage of terrain covered by snowmaking. It requires vast reservoirs of water as ski area operators try to ensure a Thanksgiving opening every year. The use of water has led to environmental battles in the state.

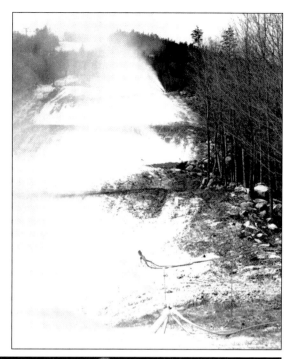

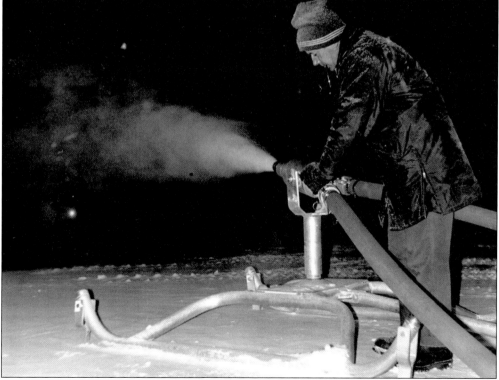

Bill Southworth, Gunstock's (formerly Belknap Mountain) number one snowmaker, adjusts a snow gun in the 1970s. Eight of these guns, it was claimed, could lay down a foot of powder over one acre in 90 minutes.

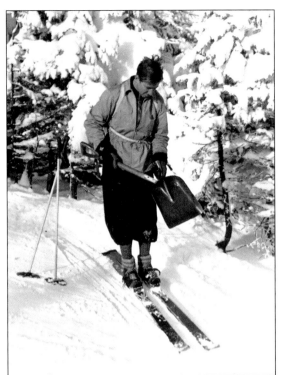

Snow in the postwar era was managed. Early efforts were done individually. Sel Hannah uses a shovel to fill in the sitzmarks, cut up the icy spots, and generally try to maintain good cover on the trail.

The hand roller seems quaint and inadequate today, but it helped keep the downhill trails, and particularly the beginner slopes, in fair shape before the advent of large-scale mechanical grooming equipment. Anyway, it is better than a harrow pulled by some folks back in the 1930s to break up an icy run.

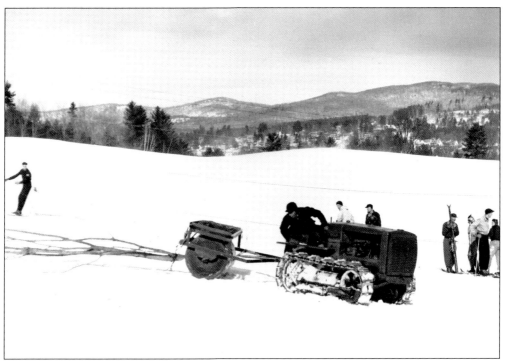

The Mount Eustis tow (in the background) brought skiers to the top of the slope now groomed by a tractor pulling a branched tree.

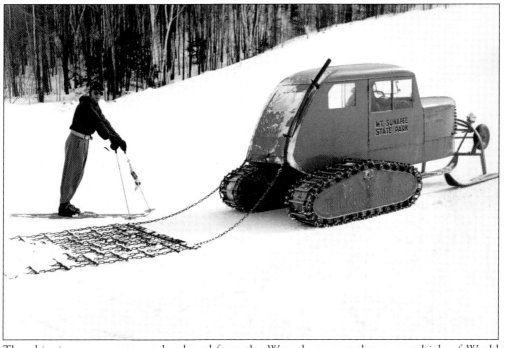

The ubiquitous snowcat was developed from the Weasel, an over-the-snow vehicle of World War II, seen here pulling a chain drag at Mount Sunapee. At that time, Sunapee was the state's other main ski area besides Cannon.

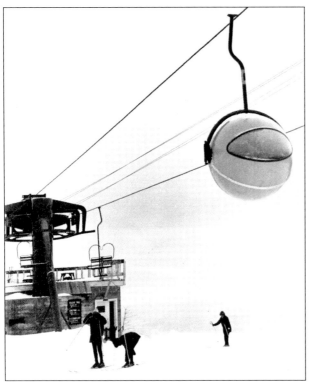

Rope tows, J-bars, T-bars, chairlifts, the tram, and now Wildcat's Astrochair, also known as the "bubble chair," all became ways to get up the mountain. Riblet's spherical enclosed ski chair was not a great success and only operated experimentally for one season in 1968–1969.

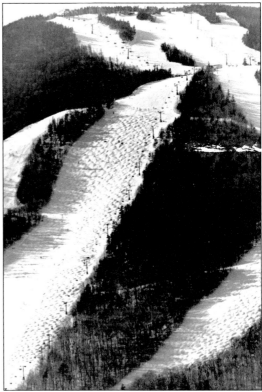

The modern ski area contains wholly separate areas for rank beginners, now called "never-evers," mostly intermediate slopes, some expert runs, a tubing park, snowboarding pipes, and bump runs such as these at Waterville Valley.

Seven

WHERE NEW HAMPSHIRE SKIS

At least 47 ski lifts of various types are operating in New Hampshire this season,
and there are fourteen ski schools at ten winter sports centers.
—The *Troubadour*, January 1946.

Sydney Shurcliff films *Ski America First*. The ski films of Arnold Fanck with Hannes Schneider and Leni Riefenstahl set the standard in the 1930s. Then came the American films of Otto Lang, John Jay, and Hans Thorner. Warren Miller and company dominate today as they extol the impossibilities for the rest of us of extreme skiing.

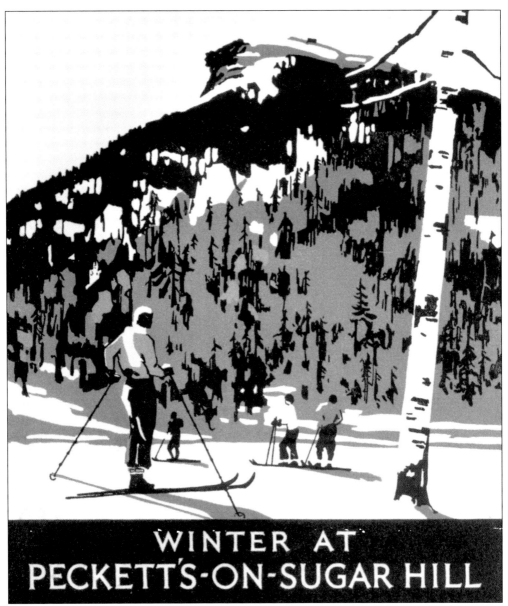

WINTER AT
PECKETT'S-ON-SUGAR HILL

Brochures were one way to advertise. Select clientele could see themselves under the gaze of the Old Man on the Mountain while enjoying their skiing leisure amongst the perfect setting provided by Peckett's on Sugar Hill in the 1930s.

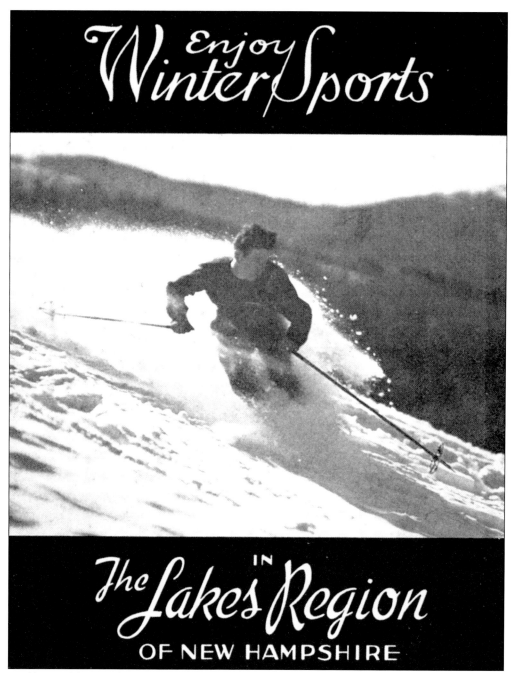

Freddie Nachbaur, Lakes Region ski guru, is promoting the area on a brochure cover. He was once refused a job as a ski instructor at St. Paul's School because he did not have an Austrian accent.

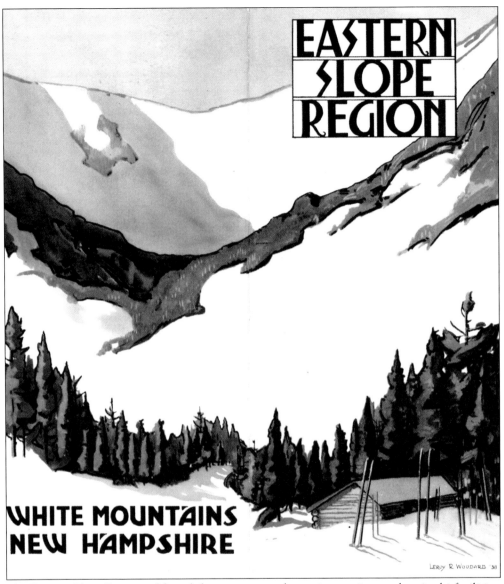

The Eastern Slope Region, although boasting tows, slopes, instruction, and après ski facilities, chose to emphasize its proximity to Tuckerman's Headwall in its brochure of the late 1930s.

The joy of the cross-country outing was the message the Concord Ski Club sent out on its 1937–1938 seasonal brochure.

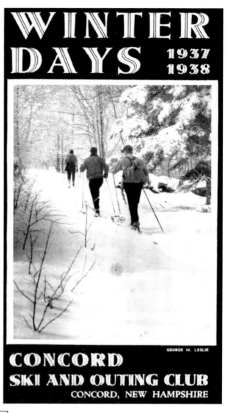

The tramway really needed no advertising. It was well known to summer and, especially, winter visitors since it was the only one in the nation.

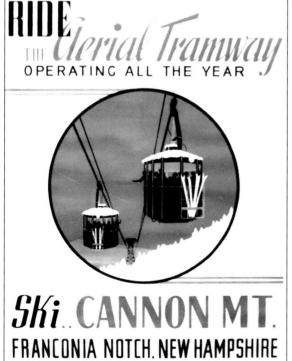

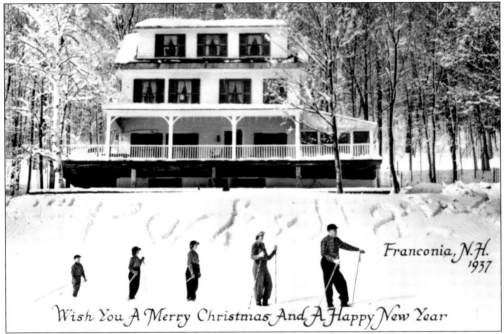

Seasonal greetings from folks staying at one of Franconia's inns were another way to publicize your hostelry and the joys of winter outdoors.

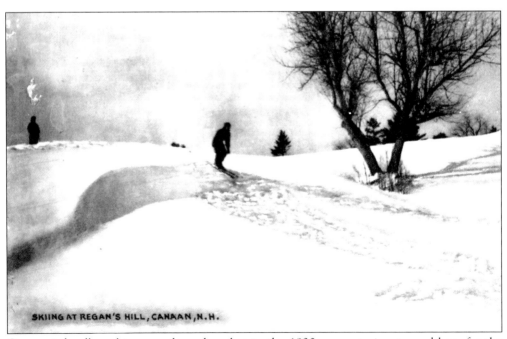

Canaan is hardly a ski mecca these days, but in the 1930s, snow trains stopped here for the crowd to dash down Regan's Hill.

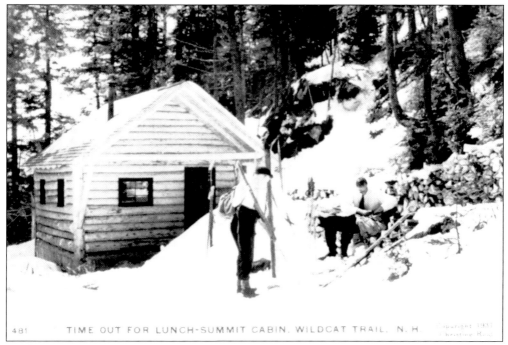

TIME OUT FOR LUNCH-SUMMIT CABIN. WILDCAT TRAIL, N. H

A Christine Reid photograph from 1937 illustrates another charm of winter in New Hampshire, this time at the Summit Cabin on Wildcat. Here, a group of friends enjoys a luncheon alfresco.

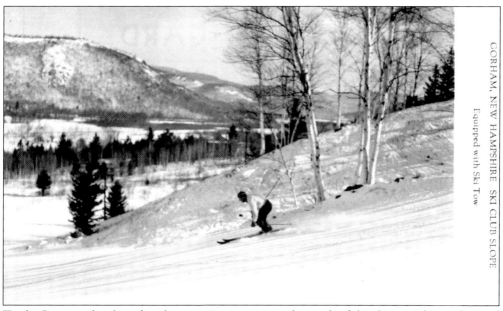

GORHAM, NEW HAMPSHIRE SKI CLUB SLOPE

Equipped with Ski Tow

Track! One wonders how fast this man is going, given the pitch of the slope on this trail served by the rope tow at Gorham.

SKI
FITZWILLIAM

FITZWILLIAM CONSERVATION CORP.
FITZWILLIAM, NEW HAMPSHIRE 03447

Ski Fitzwilliam. Near the Massachusetts border, advertising to be just one and a half hours from Boston or Springfield and only one hour from Worcester, this small area, now defunct, was associated with the Fitzwilliam Inn.

Dartmouth Winter Carnival posters are produced annually for the occasion. The older ones now sell at auction for $2,000 and up.

94

This image probably dates from the 1940s. In the years before ubiquitous television, singing was a major part of any club outing. Here it is taken one note higher, and the whole state has its own ski song. Actually, the song was never a hit.

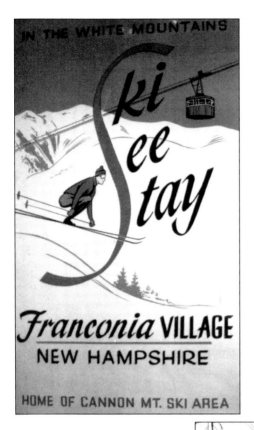

Probably painted in the late 1940s or 1950s, this poster by C.B.L. uses the schussing "S" to ski, see, and stay in the place where the Cannon Tram will let you ski to your heart's content—or till your legs give out.

Crotched Mountain, built in 1964 with a double chair, had snowmaking two years later, bought neighboring Bobcat (the old Onset) in 1987, and became an area with 26 trails and 7 lifts. The building of 100 condominiums bankrupted the area, and it closed in 1989. Crotched reopened in 2002, thanks to Peaks Resorts of St. Louis, Missouri.

Ski journalism was a new profession in the 1930s. After the war, by radio and then television, regular commentators like Cal Conniff told city folk about the best places to ski.

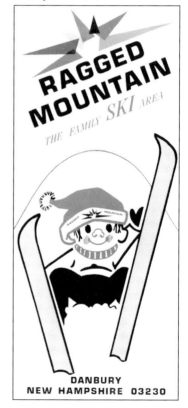

Ragged Mountain in Danbury billed itself as a family resort and relied on snow phones and the Ellis snow-reporting service out of Connecticut to extol its features and snow cover.

Pat's Peak also advertised its attractions for the family with fun for young and old on a double chair, two T-bars, and rope tows—all for $5.50 a day.

You might think that Highlands was an expert race mountain from the brochure. Started in the 1930s, it reopened with a T-bar and rope tow in the mid-1960s, and by 1980, had 22 trails and 5 lifts to serve its 7–800 vertical feet. In 1995, when the snowmaking system broke, it closed down.

Loon Mountain, Sherman Adams's mountain, reinvigorated the onetime logging town of Lincoln in the mid-1960s and has increasingly built itself into a major recreational resort, now part of Booth Creek Enterprises.

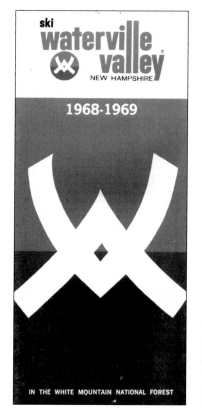

The Waterville Valley Inn hosted skiers in the 1930s but burned in the 1960s. Waterville's growth as a major real-estate development with skiing as the winter sport relied on Olympian Tom Corcoran, fifth in the downhill competitions at Squaw Valley. This area is now part of Booth Creek Enterprises too.

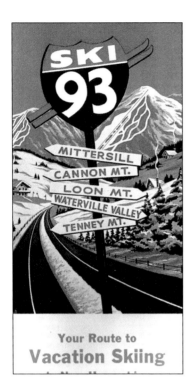

New Hampshire's answer to competition from major developments in Maine and Vermont was to create "Ski 93." Five resorts off Interstate 93 (Mittersill is now closed) were listed with interchangeable tickets.

Attitash, with its recent addition of Bear Peak, has been a pace setter. A monorail was under construction when the oil embargo hit the United States, and it was never completed. The area is now part of the American Skiing Company, which owns seven ski resorts from Maine to Utah.

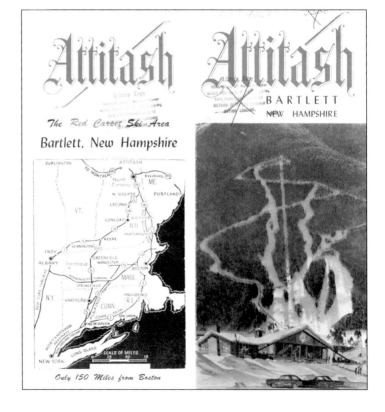

The Jackson Ski Club is the home of one of the leading cross-country centers in the eastern United States.

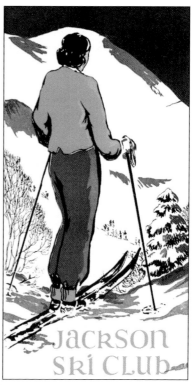

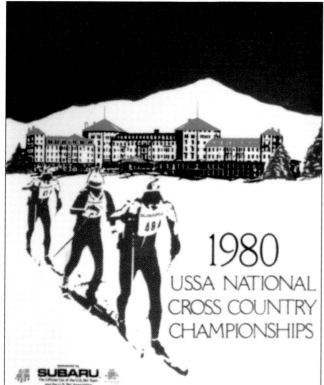

Cross-country championships at the highest level of competition were held in 1980 at Bretton Woods. There was also a biathlon course. Now, the historic Mount Washington Hotel is open for winter stays as part of the Bretton Woods ski complex.

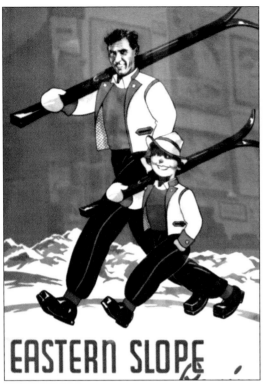

This poster is almost a replica of a popular Austrian poster. It makes sense, since the eastern slopes were dominated by Hannes Schneider and his fellow Austrians—men like Toni Matt, Franz Koessler, and Otto Scholl, who were all talented instructors.

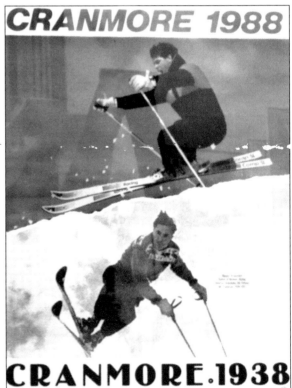

Cranmore's 50th-anniversary poster marries fast and expert skiing of the late 1980s with Hannes Schneider. Annually, the New England Ski Museum holds the Schneider Meistercup race at Cranmore in memory of Schneider and his legacy.

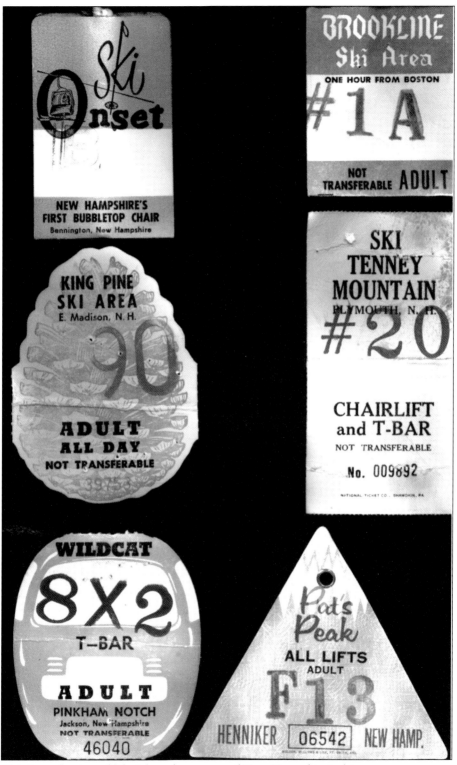

This is a selection of lift tickets from some of New Hampshire's ski areas.

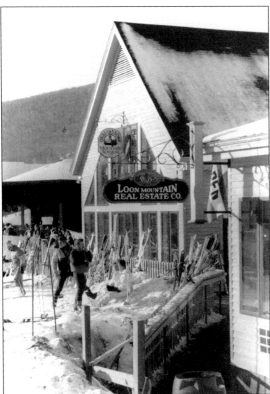

This sign of the times shows how the ski resort has become part of real-estate development. The condominium office is slope side.

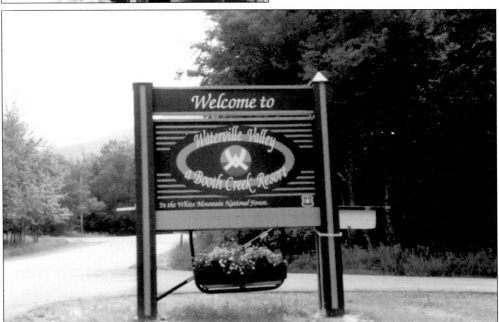

The ski resort has become part of a conglomerate. Waterville is now part of the Booth Creek organization, whose members also include neighbors Cranmore and Loon. In the West, other members are the Summit in Washington and the Californian resorts of Northstar, Sierra at Tahoe, and Bear Mountain.

Skiing is still the main winter activity at the resorts, but other attractions are offered, such as skating, indoor tennis, and sleigh rides.

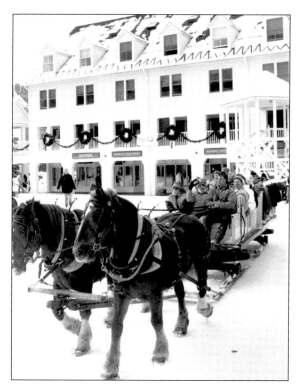

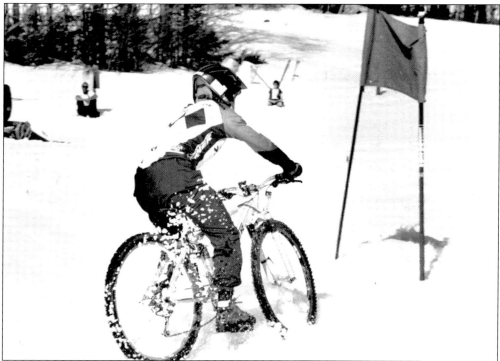

Purists may shudder, but resorts appeal to as many as possible. Mountain bikers who use the ski terrain in summer are now offered bike slaloms in winter.

New Hampshire may be, as the vans announce, "a land for all seasons," but it is also a land for all kinds of sports. Aerial displays and competitions, such as this one at Loon, bring crowds but require much special preparation of trails.

Snowboarding, some believe, has been the savior of the ski business. From the time of the oil embargo in 1973, the ski industry in the east has been flat. Snowboarding, which was on a collision course with skiing in the 1980s and early 1990s, is now a fully accepted part of every mountain's winter scene.

Algernon Chandler and Norman Libby climbed on skis to the top of Mount Washington in 1907. Libby had made a reconnaissance in 1905 but did not reach the top. There was also a man who went up in 1899, but virtually nothing is known of his trip.

Dartmouth men took trips to Mount Washington starting in 1911, some on snowshoes. Fred Harris (left) and a Dartmouth Outing Club companion take a break at the Half Way House.

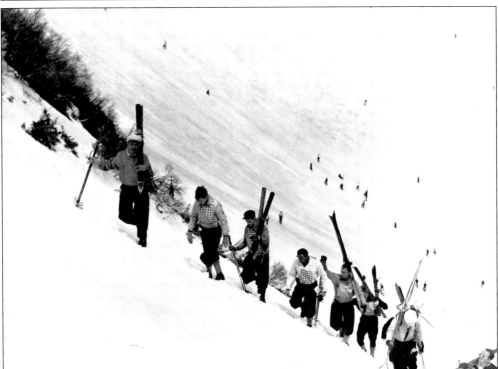

In the 1920s, the Tuckerman Bowl became a spring rite for an increasing number of people. The steep hike up drew a like-minded crowd that made Tuckerman so special for New Hampshire skiers. The tradition continues to this day.

A Winston Pote *Troubadour* cover from March 1937 captures the thrill of the Tuckerman Headwall. Pote was the leading photographer of the White Mountains in the 1930s. Later, he documented life in the 10th Mountain Division.

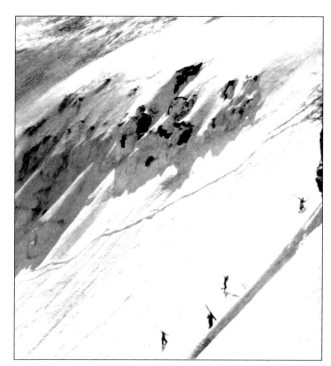

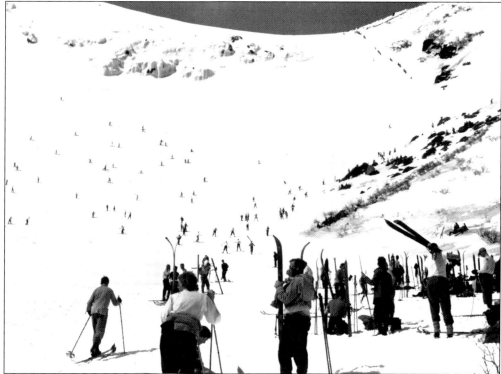

Race Day is pictured in the spring of 1935 in the Tuckerman Bowl. The hike to the Bowl takes two to three hours. This brings you first to the Little Headwall, then over the top to the Bowl with the spectacular 900-foot vertical Headwall in front of you.

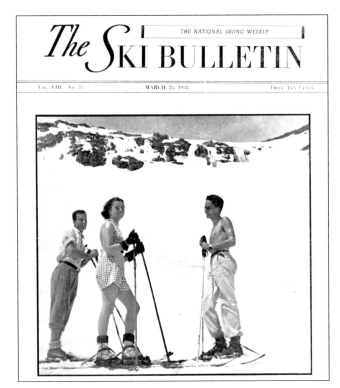

THE NATIONAL SKIING WEEKLY

The SKI BULLETIN

Vol. VIII No. 15 MARCH 25, 1938 Price Ten Cents

This is what spring skiing in Tuckerman was all about: sun and social happenings. The majority of people did not ski the Headwall; they spent their time in the Bowl.

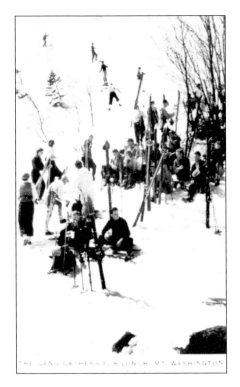

THE GANG GATHERS FOR LUNCH, MT. WASHINGTON

"Lunch Rocks" is where "the gang gathers for lunch," as in this 1937 Christine Reid photograph.

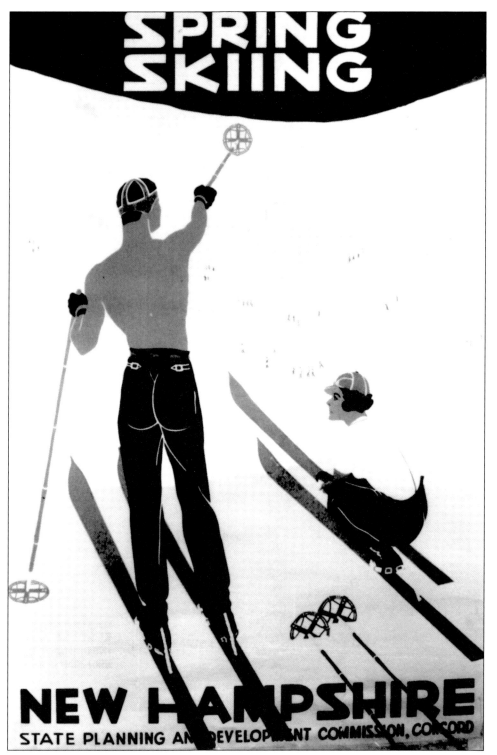

Another of the State Planning and Development Commission's posters entices city people to soak up the sun in Tuckerman's snowy bowl.

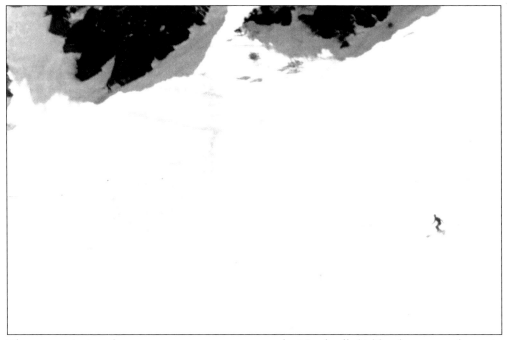

The vast majority who venture onto, or even over, the Headwall ski like the person shown in the photograph: across the snow-covered steeps. Skiers who spill slide for hundreds of yards if they are unlucky.

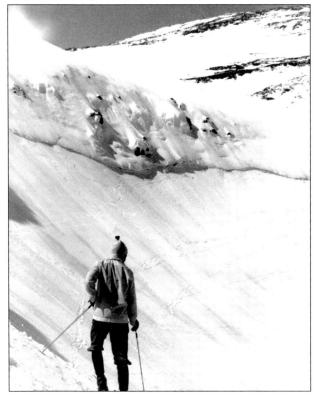

Avalanches were, and are, common in the Bowl. In the Inferno Race, now discontinued, some competitors trailed red tape from their trousers, hoping it would show should they get buried by an avalanche.

Eight

NEW HAMPSHIRE SKIERS: A GALLERY

It was kind of a fraternity; you were a skier, a little different from the rest of the people.
—Charles N. Proctor, interviewed in 1981.

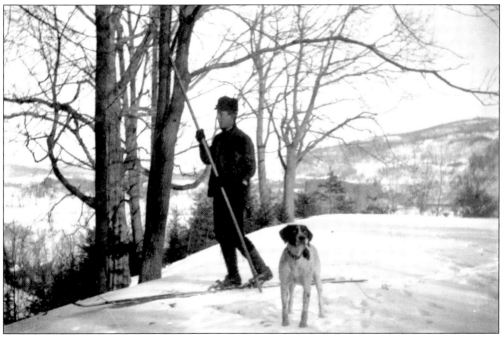

Fred Harris, founder of the Dartmouth Outing Club, the Brattleboro Outing Club, and the United States Eastern Amateur Ski Association, was the man who first suggested that Dartmouth hire a ski coach. He also represented the United States at the Fédération de Ski Congress (FIS) in Oslo in 1930.

John Carleton, Dartmouth's first ace, was a member of the U.S. Olympic team in 1924. Carleton played a major role in securing the CCC for trail cutting in the White Mountains.

Ed Blood, cross-country specialist chosen for the 1932 Winter Olympics, finished 16th out of 31 competitors in the 18-kilometer event and 18th in the jump for the "combined." Fame like this could get you on the Gaudey Company's gum cards.

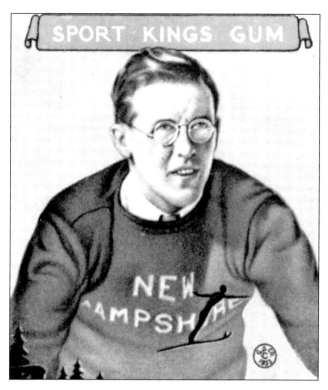

Kate Peckett traveled to Europe to find instructors for her father's inn on Sugar Hill. She was largely responsible for initiating the cutting of the Richard Taft Trail, the most challenging of New England's early downhill trails in 1932. She also had her hand in the ski fashion business as a consultant for Saks Fifth Avenue in New York.

Betty Whitney is shown in front of the AMC's Cardigan Mountain lodge in 1935. Betty and Bill Whitney ran Whitney's Inn and slopes in Jackson with its one-of-a-kind shovel-handle tow. Whitney's was one of the most popular skiing places in the eastern slope region.

Park Carpenter, here at Madison, was one of those behind-the-scenes organizers who directed the course of skiing in the late 1920s and 1930s. He was involved in the start of the *Ski Bulletin*, in arranging snow-train destinations, and heavily involved in organizing AMC ski parties.

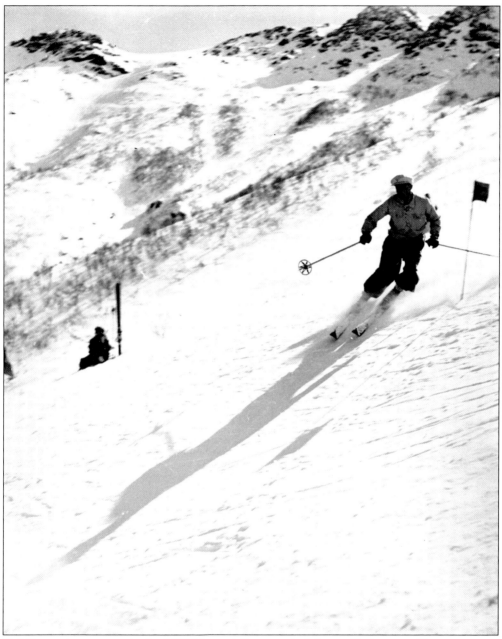

Ted Hunter is on course in the 1935 Harvard-Dartmouth slalom at Tuckerman. Hunter was one of the Dartmouth standouts in the 1930s.

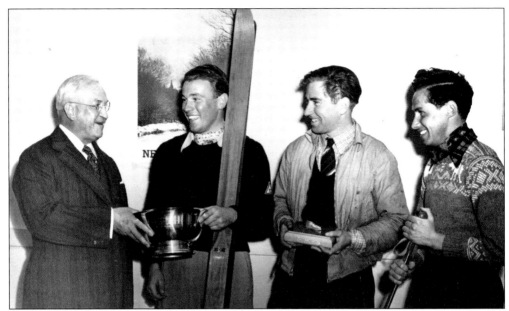

Harvey Dow Gibson, the man whose money freed Hannes Schneider to come to North Conway, presents a trophy to Toni Matt, best known for his schuss of the Headwall in the 1939 Inferno Race. Next to him are Sel Hannah, 1940 Olympian and later a builder of ski trails, and Herbert Schneider, who ran Mount Cranmore after his father's death and authored a well-known instructional manual.

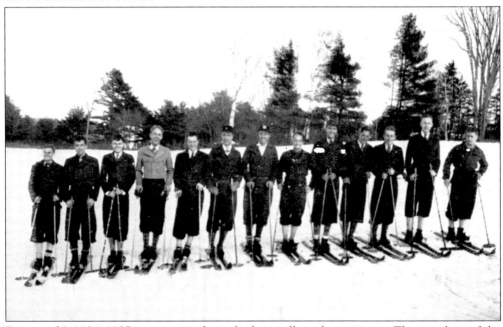

Dartmouth's 1936–1937 team was perhaps the best college ski team ever. The members of the team are, from left to right, Henry Cooke, Tige Chamberlin, Ed Merservey, Steve Bradley, Ted Hunter, Warren Chivers (captain), Dave Bradley, Dick Durrance, Howard Chivers, Walter Prager (coach), Fran Fen (manager), Bob Mussey (assistant manager), and Ed Wells. There are five Olympians here.

Mary Bird, here skiing on Mount Washington, was a member of the 1935 FIS team and the Olympic team of 1936. She played a role in the humorous film *Schlitz on Mount Washington* and taught more seriously for Carroll Reed when it was unusual to have a woman in the ski school.

Lowell Thomas is shown here on Cannon Mountain. It is difficult to measure the influence that his mellifluous radio voice had on skiing. He was a strong advocate of ski instruction American style: having fun rather than being disciplined into perfection.

Alex Bright was a founding member of Boston's Ski Club Hochgebirge, member of the FIS, participant on Olympic teams in 1935 and 1936, and was most influential in the creation of the Cannon Mountain Aerial Tramway. He not only had the idea for it but also got the ear of Gov. John Winant in 1934, and by 1938, the tram was a reality.

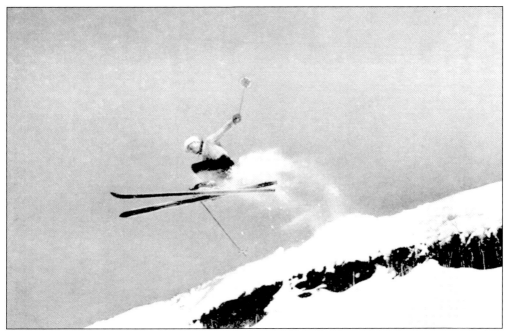

Hans Thorner displays a jump turn. One of the half dozen Swiss who came to New Hampshire in the 1930s, Thorner ran a ski school in Franconia and later at Mount Washington. After the war, he made a number of films, including one on the 1948 Olympics in St. Moritz.

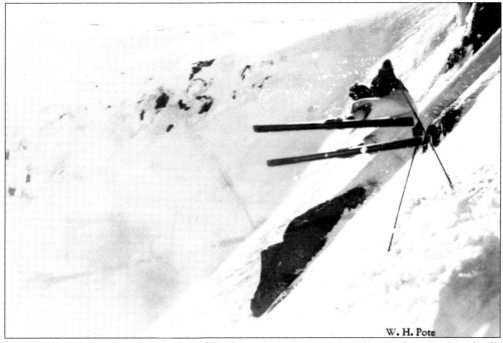

W. H. Pote

Winston Pote's camera captured Sig Buchmayr's jump turn on the Tuckerman Headwall. Buchmayr was one of the attractions of Peckett's in the early 1930s. After the war, he owned a popular ski shop in New York City.

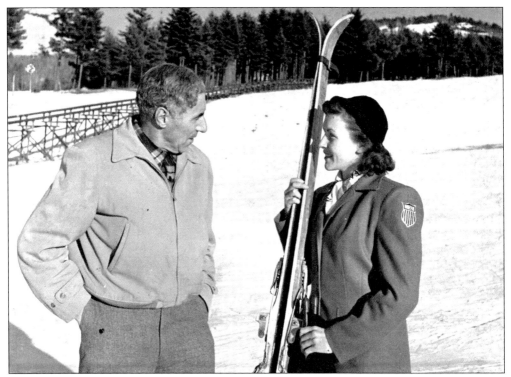

Skimeister Hannes Schneider sends off Paula Kann (later Paula Valar) to the 1948 Olympics. She finished 11th in the special slalom. Later, she became a well-known instructor, specializing in fun and games for children, and was featured in a major article in *Life* magazine.

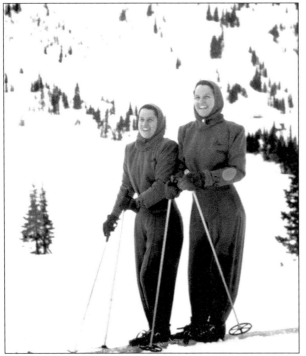

The dean of Dartmouth's twin daughters, Sally and Susan Neidlinger, were photographed on a western holiday in 1947. Sally went on to the U.S. Olympic team in 1952, and Susan was a prominent racer in the east and later a force in the New Hampshire legislature.

These are two New Hampshire entrepreneurs. Pete Seibert, from Bartlett, built Vail, Colorado, after his service in the 10th Mountain Division. Tom Corcoran started Waterville Valley, which became one of the state's most popular areas.

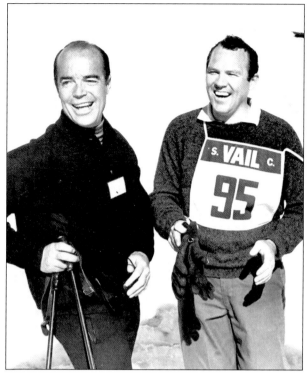

Tom Corcoran built Waterville Valley's skiing reputation by providing excellently groomed slopes for beginners and intermediate skiers as well as many racing courses for World Cup events.

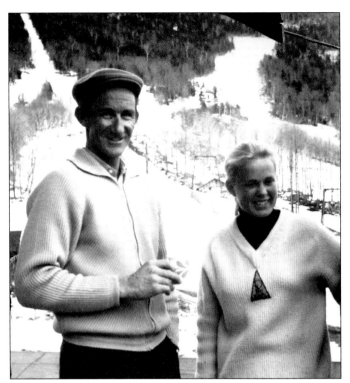

Paul Valar, onetime member of the Swiss team, was the longtime director of two ski schools at Cannon Mountain and Sunapee and one of the founders of the Professional Ski Instructors of America. He is chatting with Penny Pitou, Olympian of 1956 and a double silver medallist in the downhill and the giant slalom at Squaw Valley in 1960.

Roger Peabody, executive director of the United States Eastern Amateur Ski Association, is shown with 1968 Olympian Suzy Chaffee. Chaffee became better known for her interest in ballet skiing.

Gordy Eaton was on the Olympic teams in 1960 and in 1964 as well as on the FIS team in 1962. He later coached the U.S. ski team. He is seen here running in the third New England Kandahar in 1959.

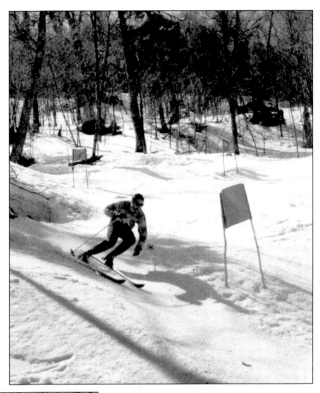

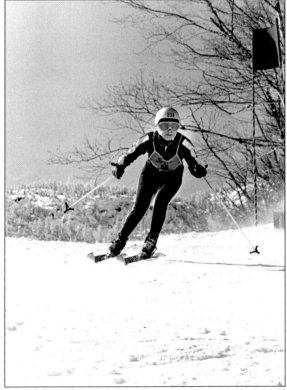

Joan Hannah was a member of the Olympic teams in 1960 and 1964 and the FIS team in 1962 where, at Chamonix, she won a bronze medal in the giant slalom. Later, she instructed at Vail for many years.

An anonymous blind skier is guided by the skier in front. New Hampshire areas—Sunapee, Waterville, Loon, and others—have made efforts to promote skiing for the disabled with special programs and facilities.

New Hampshire's latest star, Bode Miller, trained with the Franconia Ski Club and went on to win two silver medals in the 2002 Salt Lake City Winter Olympics.

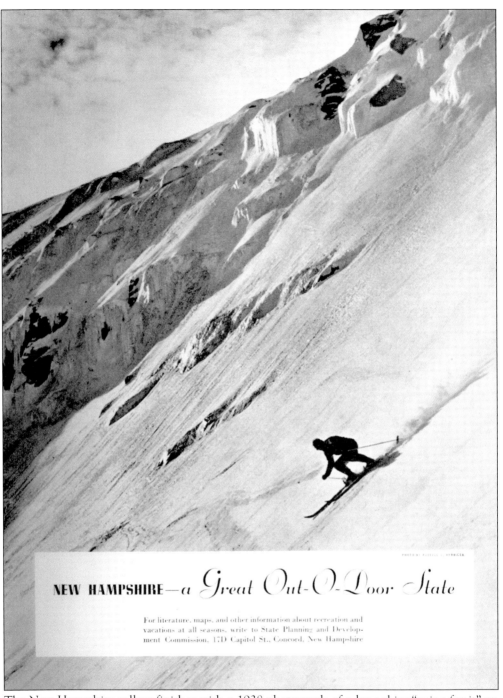

NEW HAMPSHIRE—*a Great Out-O-Door State*

For literature, maps, and other information about recreation and vacations at all seasons, write to State Planning and Development Commission, 17D Capitol St., Concord, New Hampshire

The New Hampshire gallery finishes with a 1938 photograph of a lone skier "going for it" on the Tuckerman Headwall, something skiers all over the country dream about. It is part of the mystique of New Hampshire.